L♥VE
LONDON

Barbara Chandler

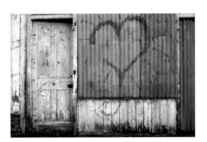

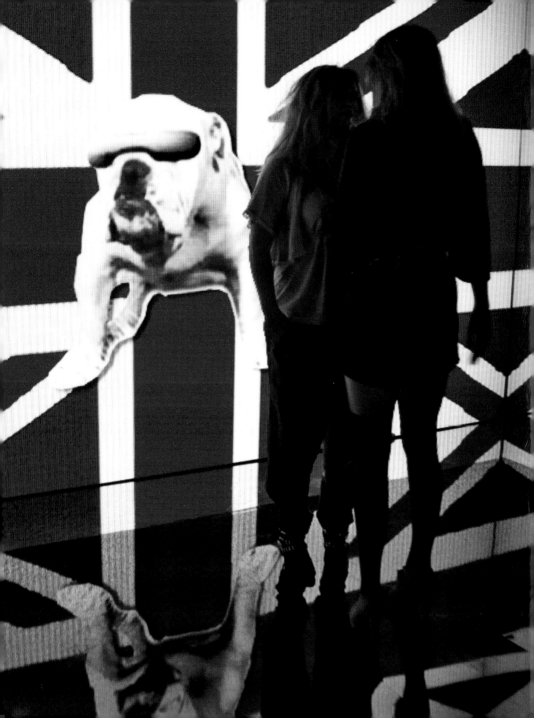

L♥VE
LONDON

Barbara Chandler

With much love luck

for

Barbara

Dedication

For my husband Ben Tewson.

First published in the United Kingdom
in 2011 by
Batsford
10 Southcombe Street
London W14 0RA

An imprint of Anova Books Company Ltd

ISBN: 978-1-849940-11-5

A CIP catalogue record for this book is available from the British Library.

19 18 17 16 15 13 12 11
10 9 8 7 6 5 4 3 2 1

Design by Lee-May Lim
Reproduction by Mission Productions Ltd, Hong Kong
Printed by Toppan Leefung Printing Ltd, China

This book can be ordered direct from the publisher at the website
www.anovabooks.com or try your local bookshop.

Previous page: Party installation, Shoreditch, 2009

Marylebone Road, 2009

Introduction

London is on a roll. It is now the 'capital of the world,' the BBC has said – though they may be biased. The forthcoming London Olympics and the Queen's Diamond Jubilee in 2012, and the celebrations surrounding the Royal Wedding in 2011, have added to the feel-good factor.

Vibrant, buzzing, thrilling London is home to 7.5 million people speaking over 300 languages. It is a slick international centre of finance but two thirds of its area is covered in green space or water. An ever-expanding fan club at home and abroad loves London's history, buildings and (free) museums and galleries. There is the fashion, theatre, music, cinema, newspapers, clubs, sport – and even, these days, the food. And definitely the shopping!

A Twitter #lovelondon 'hash-tag' – which is like a giant filing cabinet for tweets worldwide – collects global praise in 140 characters daily. London's pull is also powerfully political. Ken Livingston, the first elected Mayor (from 2000–2008) says that dreams come true in London 'where freedom is strong and people can live in harmony'.

I've been taking photographs that celebrate London for 25 years. As soon as the light's right – and often when it's not – I've been out with my camera, endlessly wandering and wondering. London has been an unfailing source of imagery, but how best to put it in order, to present it?

London has a huge literary archive, which has inspired poets, novelists, playwrights, diarists and now bloggers for centuries. My idea was to try and match snippets of what has been marvellously said to my photographs.

London of course can be maddening – indeed enraging. On the downside are the traffic, the weather, pricey fares, food, drink and hotels. Londoners are famously cheerful – but paradoxically love to moan. And undeniably there is a dismal gap between rich and poor.

In fact writers have always seen it both ways. The poet Percy Bysshe Shelley's praise is literally set in stone on the South Bank (see photograph opposite). But he also said London was hell. Dr Samuel Johnson, author of London's most famous quote ('When a man is tired of London, he is tired of life', see page 139) also condemned its 'rabble rages' and poverty. Artist-poet William Blake saw visions of Jerusalem but also tears and woe. Charles Dickens lashed out at pollution, fog and social deprivation. Sadly, the latter lingers,

but salmon now leap up the River Thames and there are clear views from City high points to the north and south.

In *London: A Biography*, the Acton-born author Peter Ackroyd, created a poetic animus for our city, where the spirit is as powerful as the place. London is 'illimitable' he says.

Which is of course the sheer joy of it all. Whatever we do as Londoners or visitors, we'll never get to the bottom of it all. So just accept it – it's strangely liberating. There is always more to experience and to see. Choosing the right photographs from a vast pictorial reservoir was a huge challenge and responsibility. London writing – and there is so much of it – is brilliantly poetic and/or dramatic, intriguing, witty, quirky, informative, even subversive. But then photographs can be that too. I hope I've achieved some happy partnerships, but you will be the best judge of that.

With much *Love London* from,

Barbara

The South Bank, 1992

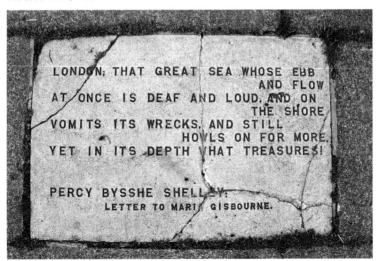

LONDON; THAT GREAT SEA WHOSE EBB
AND FLOW
AT ONCE IS DEAF AND LOUD, AND ON
THE SHORE
VOMITS ITS WRECKS, AND STILL
HOWLS ON FOR MORE,
YET IN ITS DEPTH WHAT TREASURES!

PERCY BYSSHE SHELLEY:
LETTER TO MARIA GISBOURNE.

"Every city has a sex and an age which have nothing to do with demography. London is a teenager, an urchin, and, in this, hasn't changed since the time of Dickens."

The Guardian,1987, **John Berger (1926–),** British writer and critic

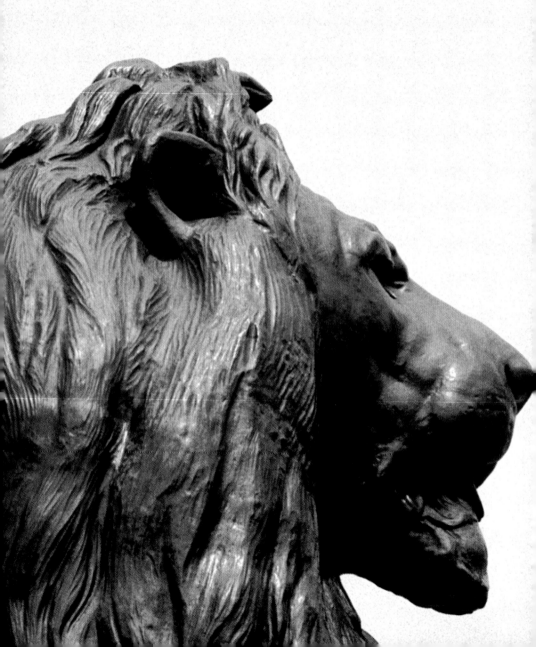

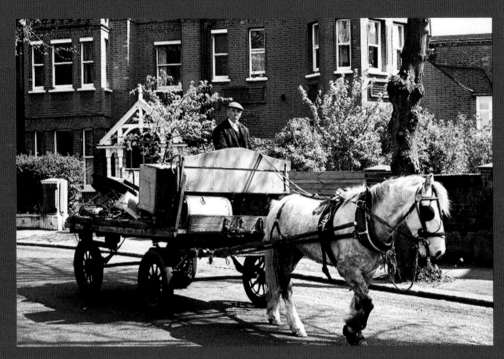

Acton, 1986

"England is a paradise for women and hell for horses;
Italy is a paradise for horses, hell for women,
as the proverb goes."

The Anatomy of Melancholy, 1621, **Robert Burton (1577–1640)**,
English scholar and cleric

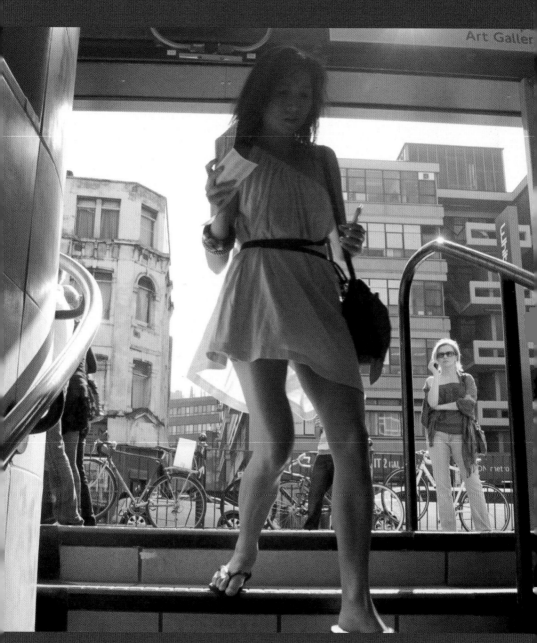

Art Galler

Aldgate , 2009

"I think that it
is the best club
in London."

Mr Twemlow, *Our
Mutual Friend*, 1865
**Charles Dickens
(1812–1870),**
English writer

Hackney, 1999

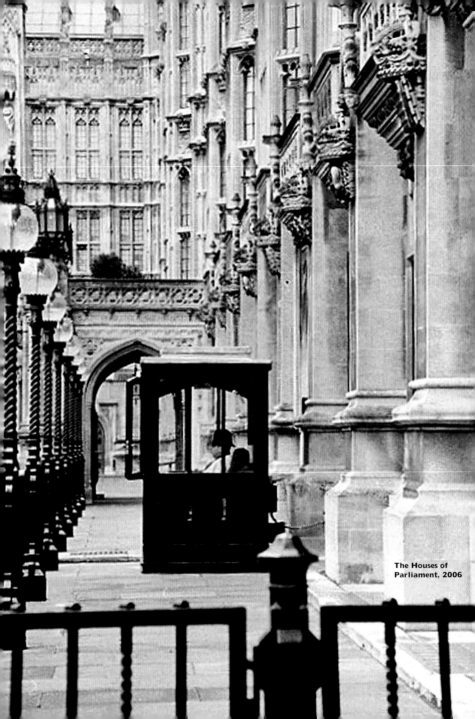
The Houses of
Parliament, 2006

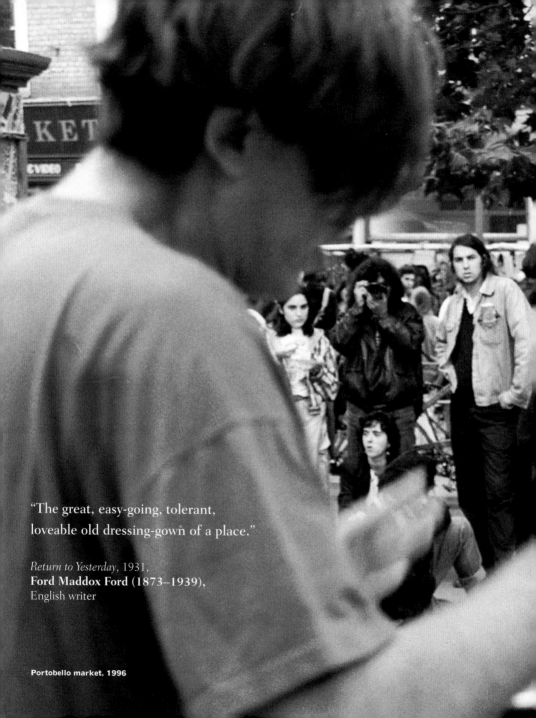

"The great, easy-going, tolerant, loveable old dressing-gown of a place."

Return to Yesterday, 1931,
Ford Maddox Ford (1873–1939),
English writer

Portobello market, 1996

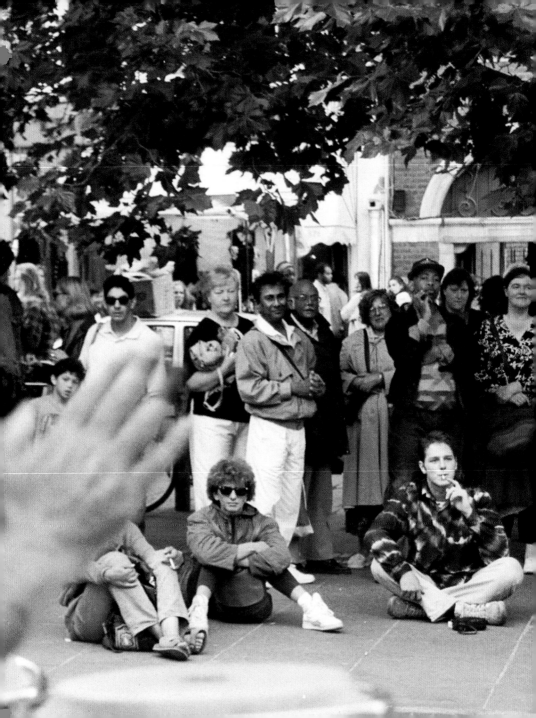

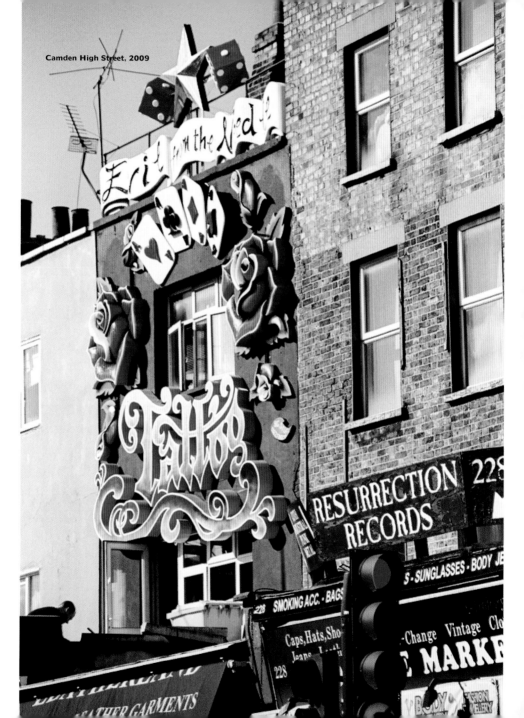

Camden High Street, 2009

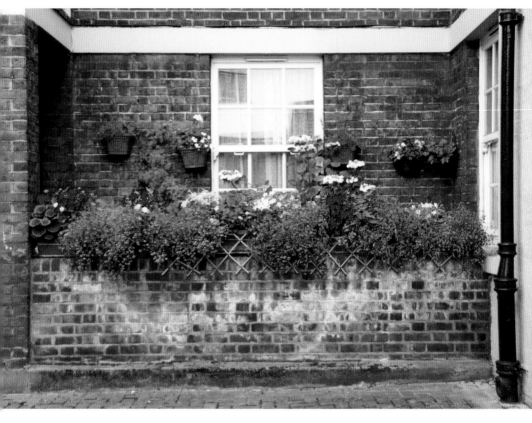

"London, thou art the flower of cities all."

In Honour of the City of London, **William Dunbar (c1456–c1520),**
Scottish poet

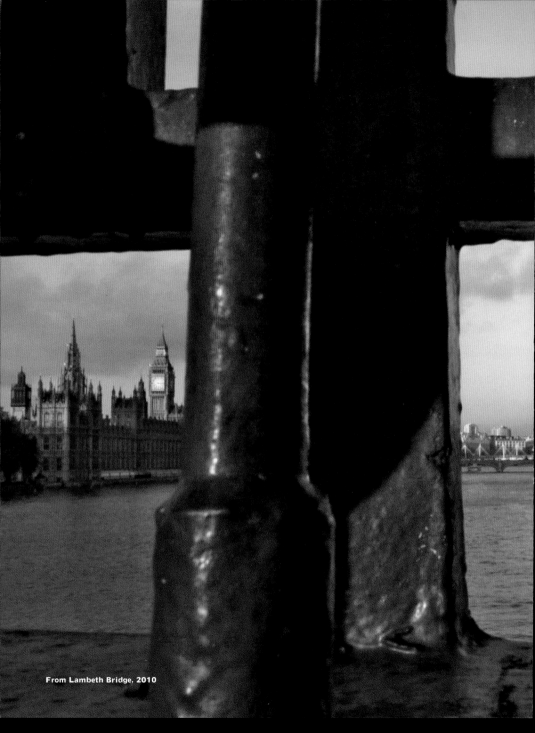
From Lambeth Bridge, 2010

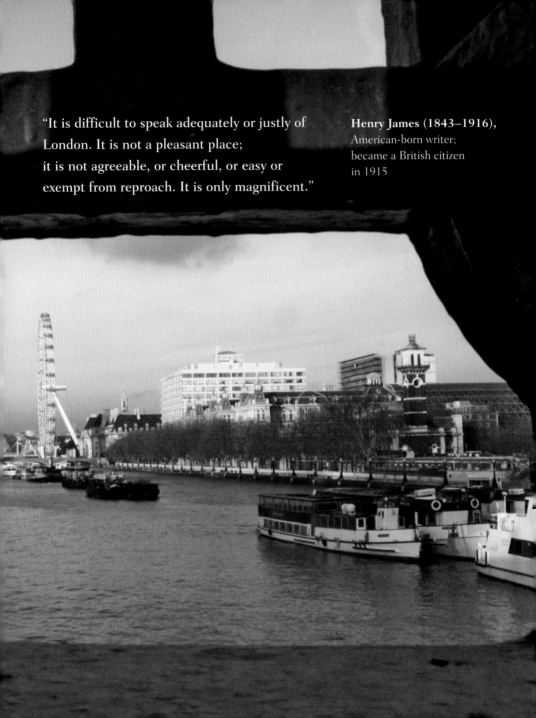

"It is difficult to speak adequately or justly of London. It is not a pleasant place; it is not agreeable, or cheerful, or easy or exempt from reproach. It is only magnificent."

Henry James (1843–1916), American-born writer; became a British citizen in 1915

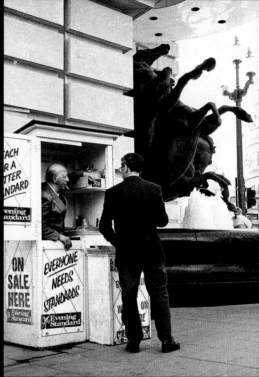

Kensal Rise, 2010

Piccadilly, 1994

"I like the English.
They have the most rigid code of immorality in the world."

Eating People is Wrong, 1959, **Malcolm Bradbury (1932–2000),**
British author and academic

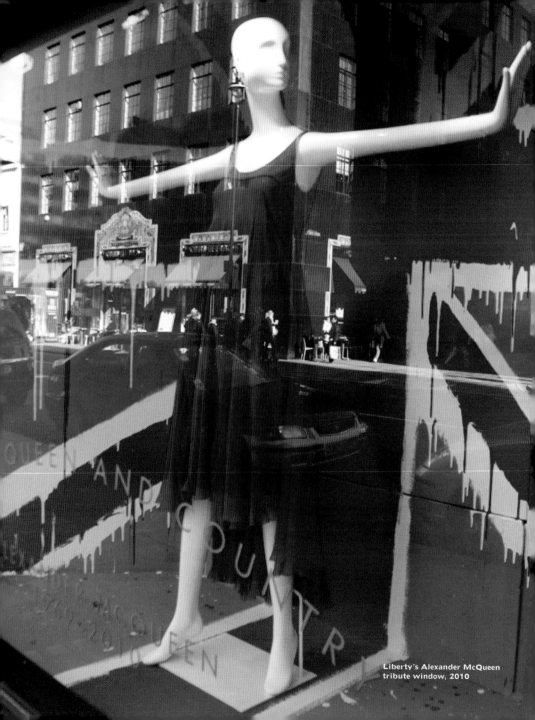

Liberty's Alexander McQueen
tribute window, 2010

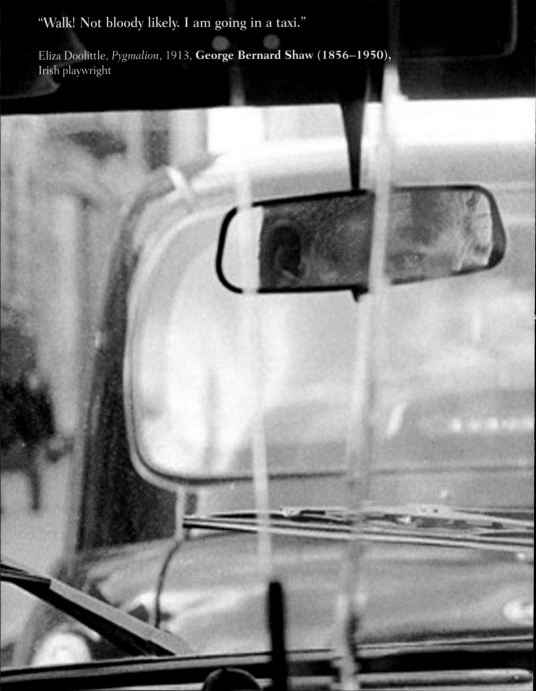

"Walk! Not bloody likely. I am going in a taxi."

Eliza Doolittle, *Pygmalion*, 1913, **George Bernard Shaw (1856–1950),**
Irish playwright

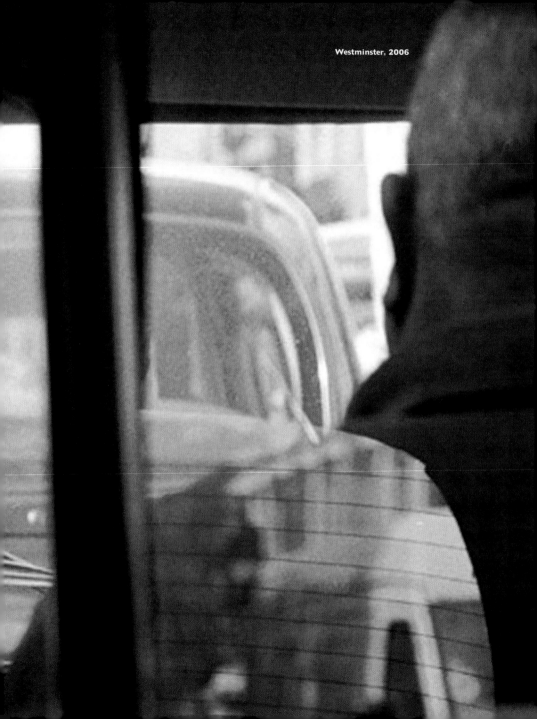

Westminster, 2006

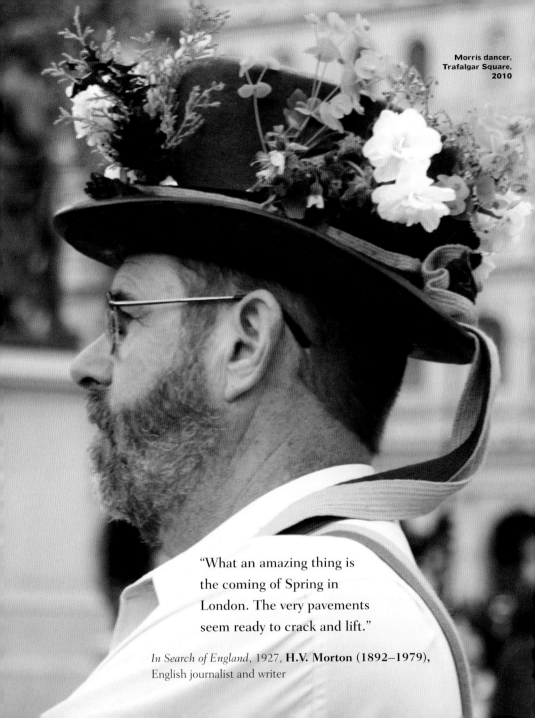

"What an amazing thing is
the coming of Spring in
London. The very pavements
seem ready to crack and lift."

In Search of England, 1927, **H.V. Morton (1892–1979)**,
English journalist and writer

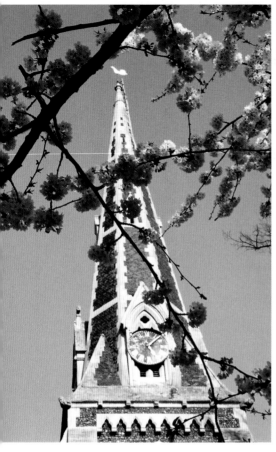

Turnham Green, 2007

West Ealing, 2010

"Oh, to be in England
Now that April's there."

Home-thoughts, From Abroad, 1845,
Robert Browning (1812–1889),
English poet

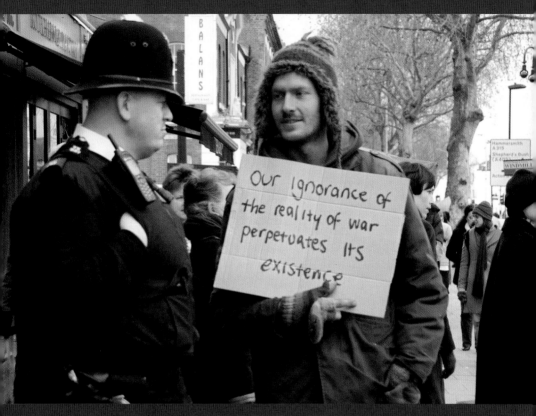

Chiswick High Road, 2010

"The first sign of age ... is when you go out into the streets of London and realise for the first time how young the policemen look."

Seymour Hicks (1871–1949), British actor, writer and producer

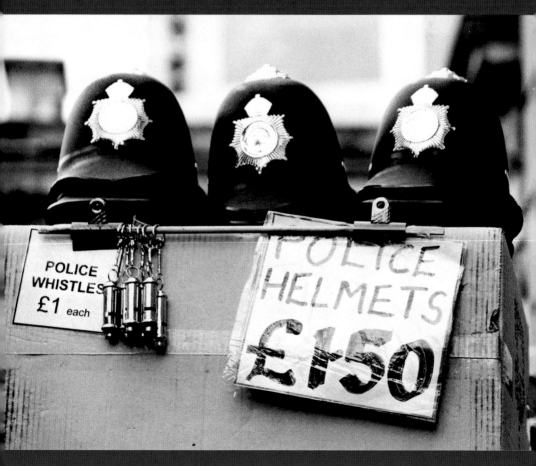

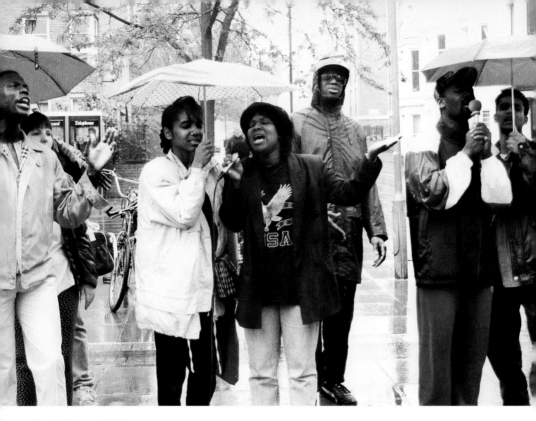

Portobello Road, 1995

"Now in contiguous drops the flood comes down
Threatening with deluge this devoted town."

A Description of a City Shower, 1710,
Jonathan Swift (1667–1745), Anglo-Irish poet

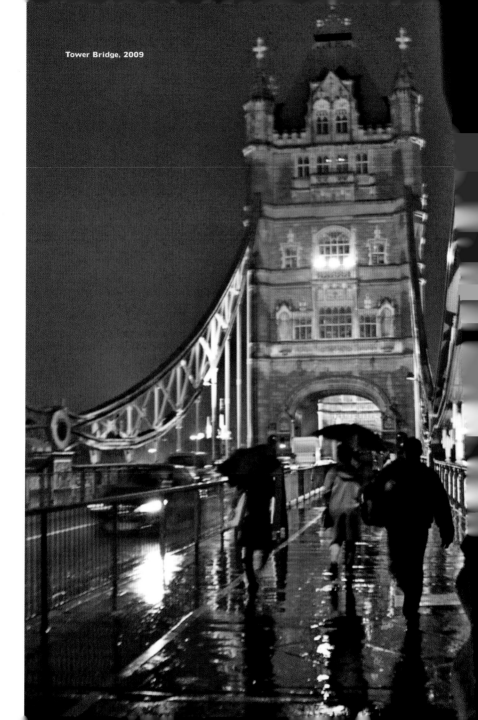

Tower Bridge, 2009

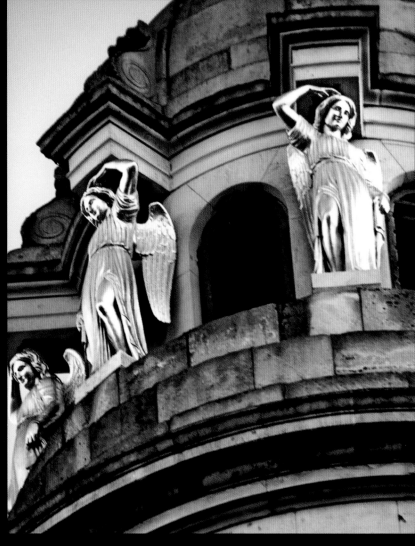

St Marylebone Church, 2009

"Daughters of London ... You which are angels."

Epithalamion *Made at Lincoln's Inn*, **John Donne (1572–1631),** English poet

Fountain at St Paul's Cathedral, 2002

"Non Angli sed angeli."
(Not Angles but Angels.)

On seeing English slaves
in Rome,
Pope Gregory (c540–604)

St Paul's Cathedral, 2004

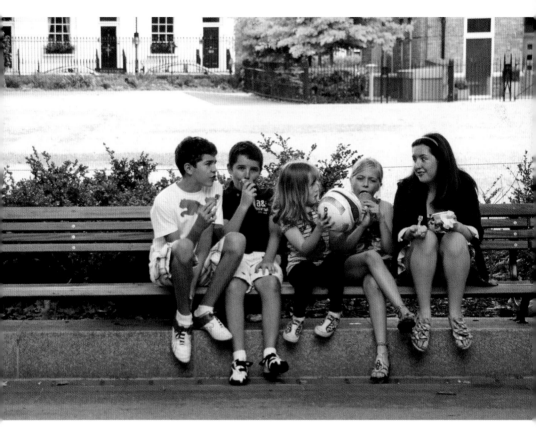

King's Road, Chelsea, 2010

"I'm leaving because the weather is too good.
I hate London when it's not raining."

Groucho Marx (1890–1977), American comedian and film star

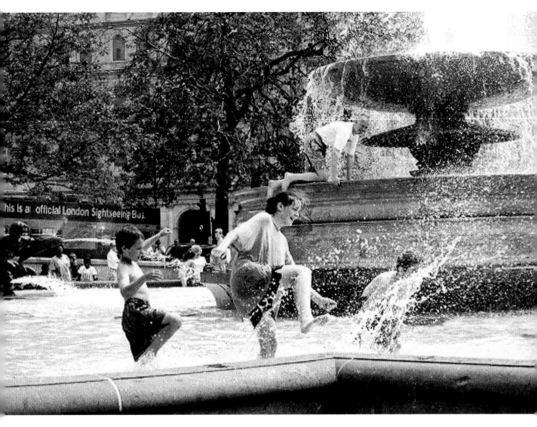

Trafalgar Square, 1996

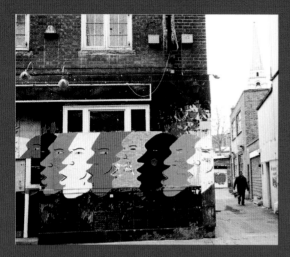

Brick Lane, 2009

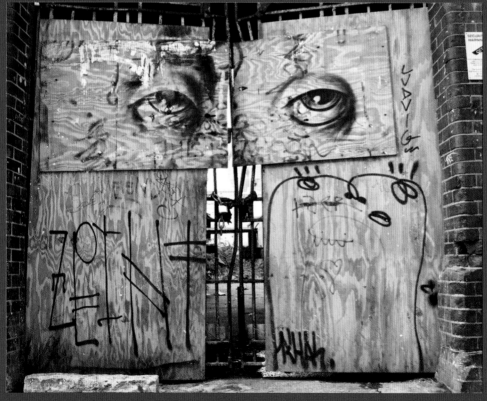

"Graffiti is the most honest art form available."

Wall and Piece, 2005, **Banksy (1974–)**,
British graffiti artist

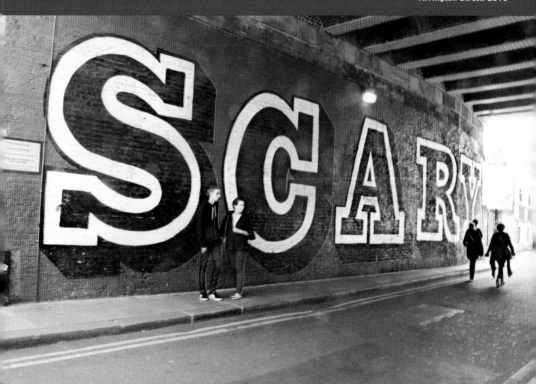

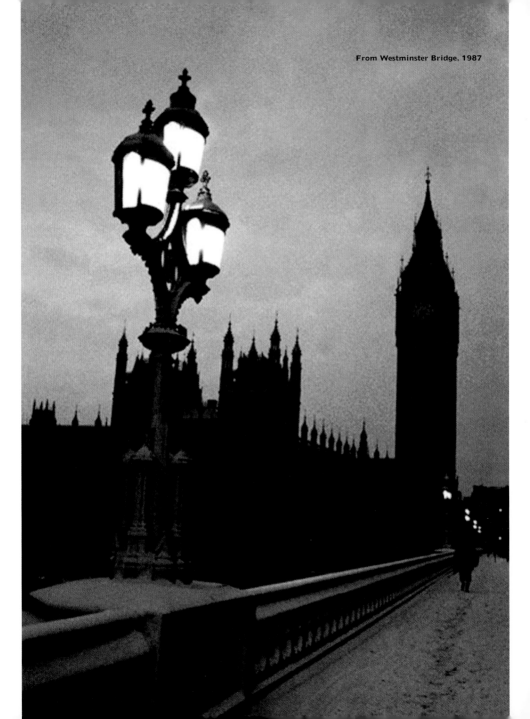

From Westminster Bridge, 1987

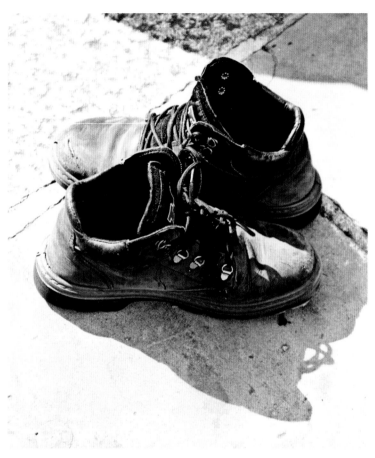

"I know what it looks like when the sun's setting behind
Westminster Abbey and the Houses of Parliament
and ... in the winter with snow and fog. When I saw
this painting I felt how much I love London."

Letter to his brother Theo, 1875,
Vincent Van Gogh (1853–1890), Dutch painter

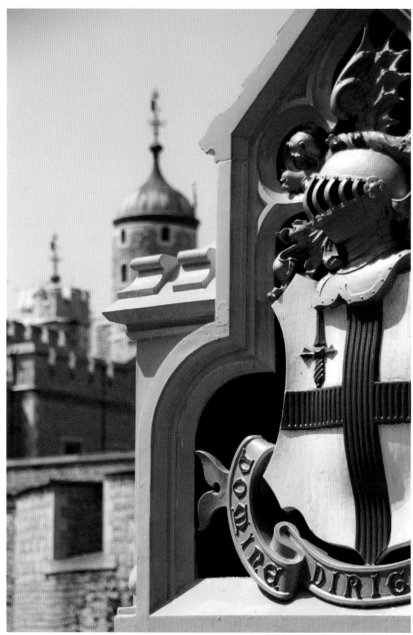

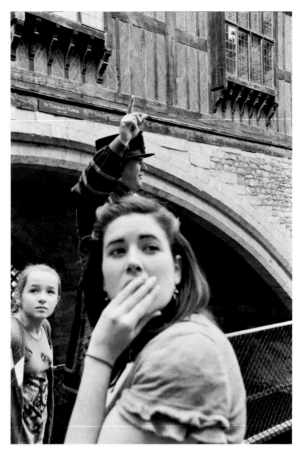

Beefeater at the Tower of London, 2009

"Is not this house [the Tower of London]
as nigh heaven as my own?"

Sir Thomas More (1478–1535),
English scholar, chancellor and saint; executed on Tower Hill

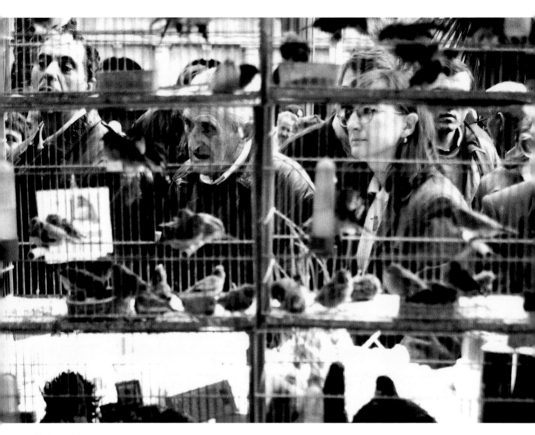

Hackney, 1999

"London is a roost for every bird."

Lothair, 1870, **Benjamin Disraeli (1804–1881),**
British Prime Minister and novelist

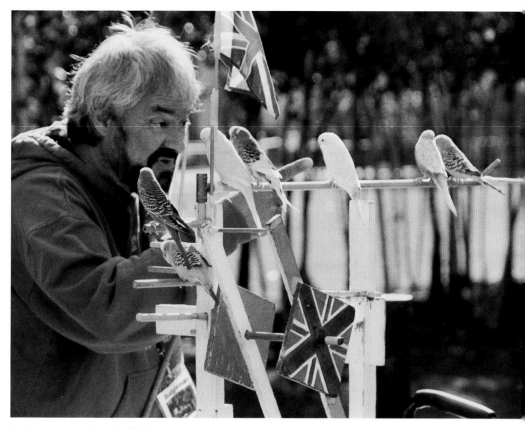

The Budgieman, South Bank, 2008

Oxford Street, 2009

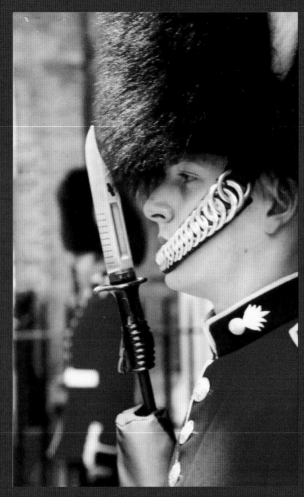

St James's Palace, 2008

"The British soldier, who thought himself
superior, actually became so."

Canada Military Journal, 1787,
John Graves Simcoe (1752–1806),
First Lieutenant Governor of Upper Canada

43

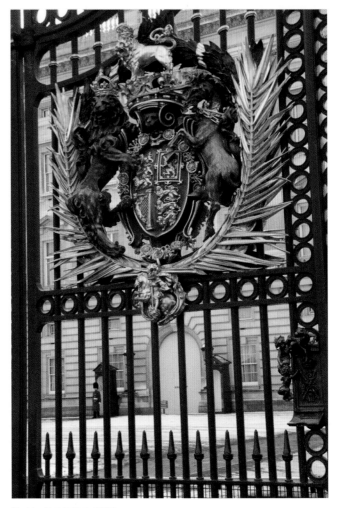

Buckingham Palace, 2009

"I am speaking to you from my own home, where
I am spending Christmas with my family."

First Christmas broadcast, 1952,
Her Majesty Queen Elizabeth II (1926–), Queen of the
United Kingdom and 15 other Commonwealth countries

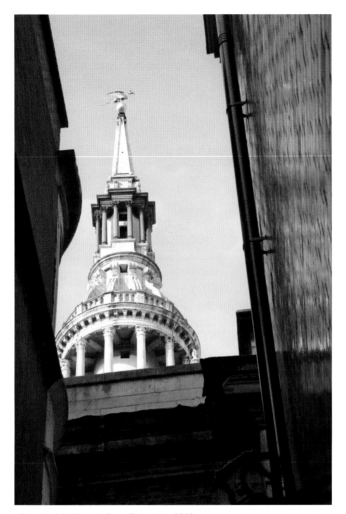

Church of St Mary-le-Bow, Cheapside, 2010

"Clarke of the Bow belle with the Yellow lockes,
For thy late ringing thy head shall have knockes."

London medieval rhyme

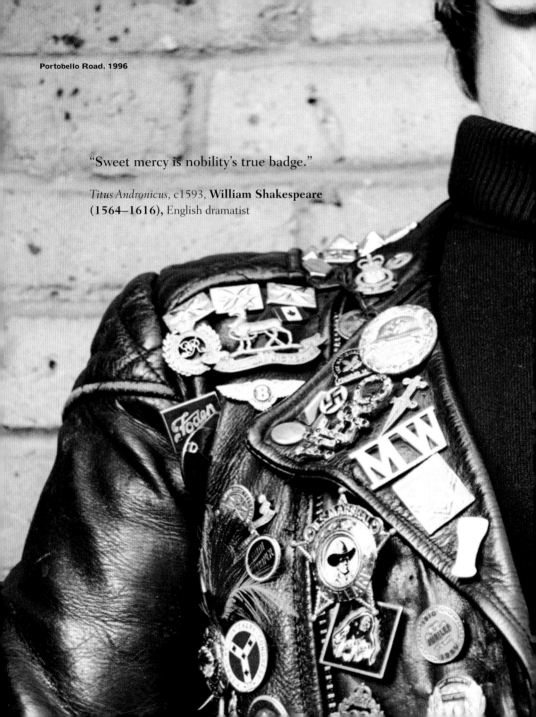

"Sweet mercy is nobility's true badge."

Titus Andronicus, c1593, **William Shakespeare (1564–1616),** English dramatist

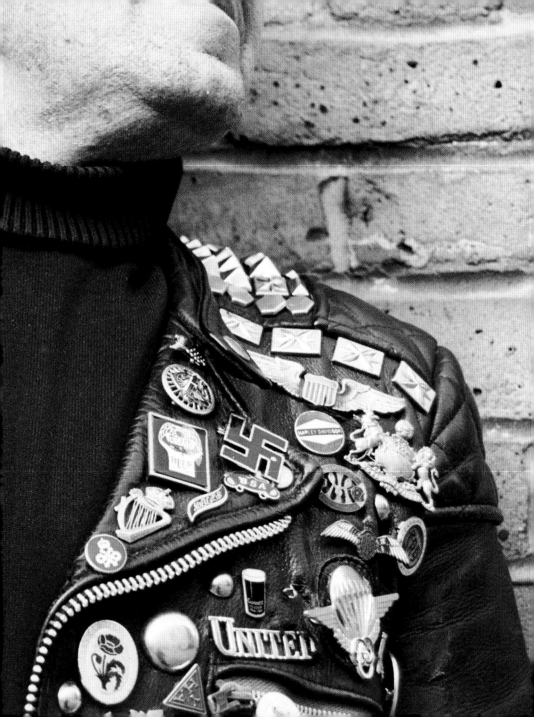

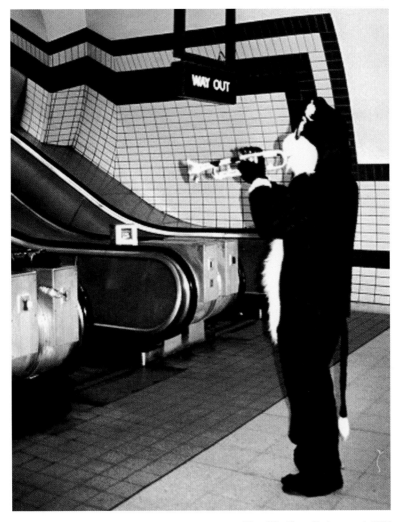

Piccadilly Circus Underground, 1994

"Turn again Whittington!
Thrice Lord Mayor of London."

Dick Whittington and his Cat, **James Orchard Halliwell-Phillipps
(1820–1889),** English collector of fairytales and nursery rhymes

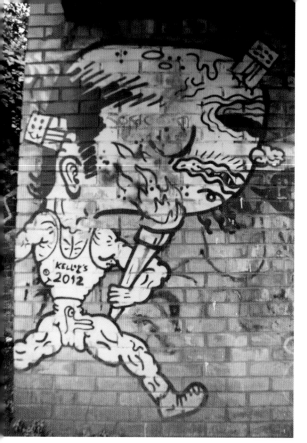

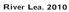
River Lea, 2010

"The amazing dream is becoming a reality – this is great for the East End and for sport."

www.london2012.com, 2010,
David Beckham (1975–),
British footballer

East London Olympic site, 2010

Piccadilly, 1986

"[London's] extraordinary people ... are too eclectic to pigeonhole ... entrepreneurs and eccentrics, sports heroes and moneymen, poets and rock stars."

London Evening Standard, November 2010,
Geordie Greig (1960–), British newspaper editor

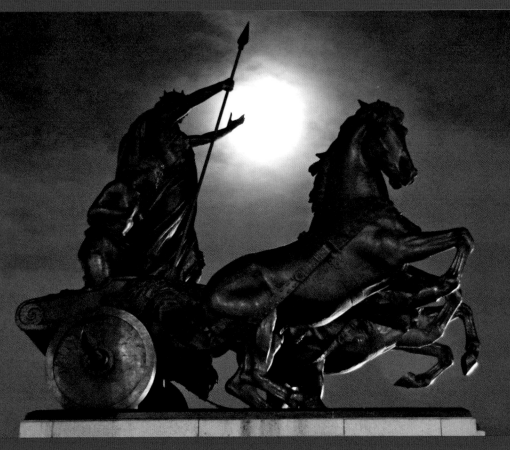

Statue of Boadicea, Westminster, 2010

"Here then in London build the city of the free."

The Londoners, 1938, **W.H. Auden (1907–1973),**
born in Britain; became an American citizen in 1946

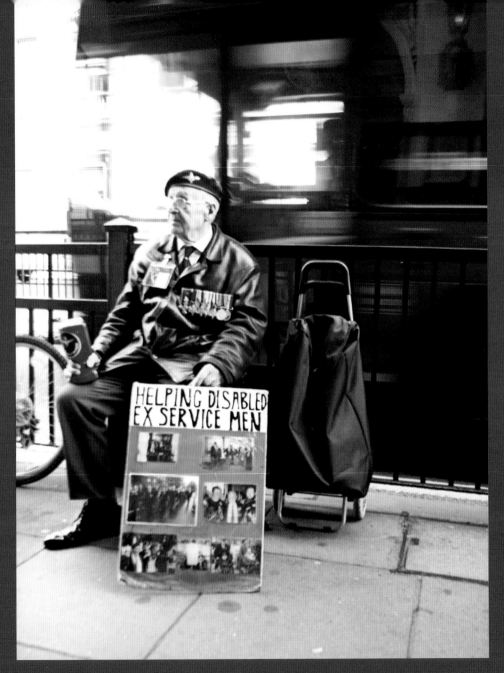

Piccadilly, 2010

Islington, 2010

"No foteball player be used or suffered within the City of London ... upon pain of imprisonment."

Queen Elizabeth I (1533–1603), Queen of England

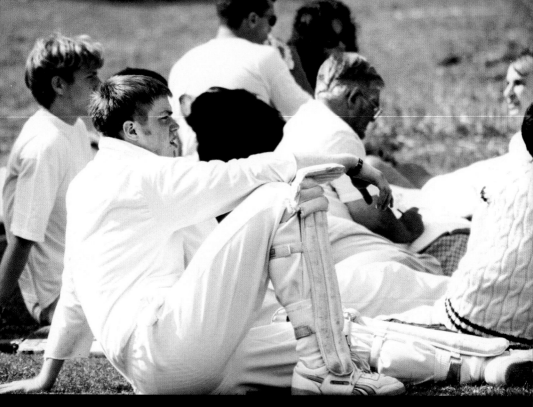

Hackney, 1999

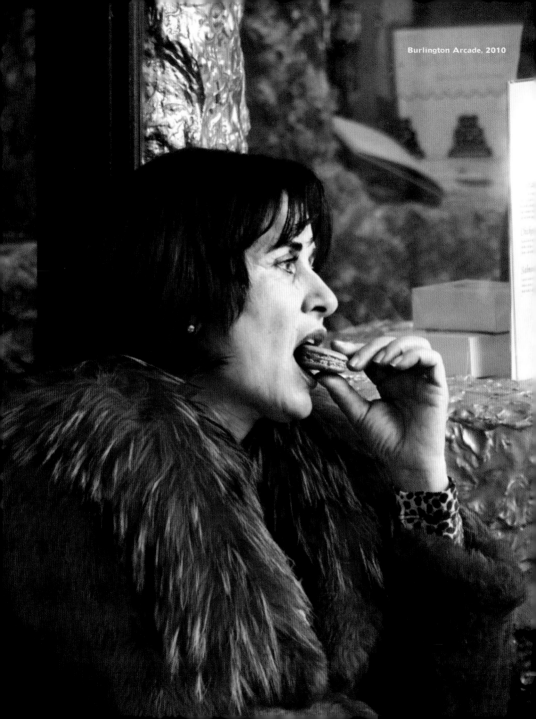

Burlington Arcade, 2010

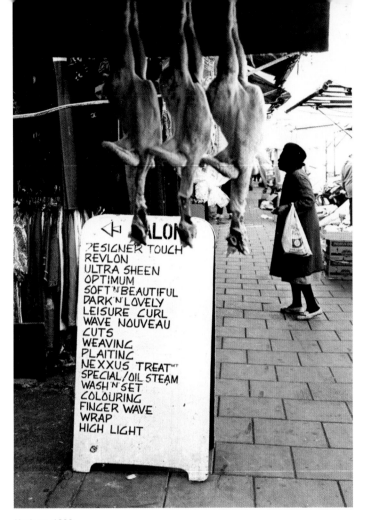

Hackney, 1999

"A very famous city,

Where the streets are paved with gold,

And all the maidens pretty."

The Heir at Law, 1808, **George Colman the Younger
(1762–1836),** English playwright and poet

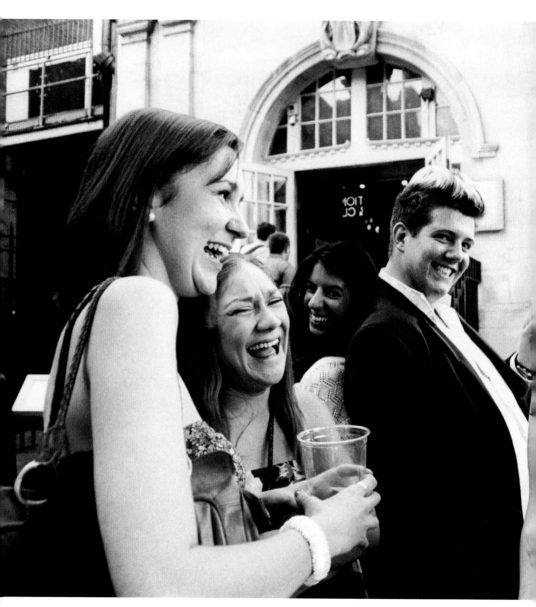

Outside Embankment Underground, 2009

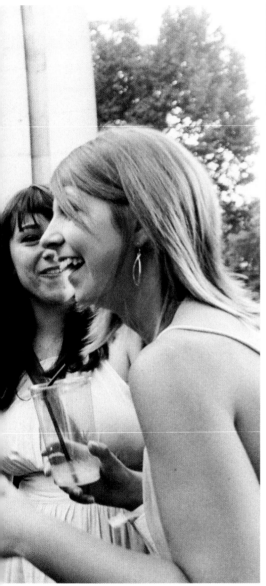

Soho, 2010

"Our scene is London,
'cause we would make it known.
No country's mirth is better
than our own."

Prologue to *The Alchemist*, 1610,
Ben Jonson (c1572–1637),
English poet and playwright

59

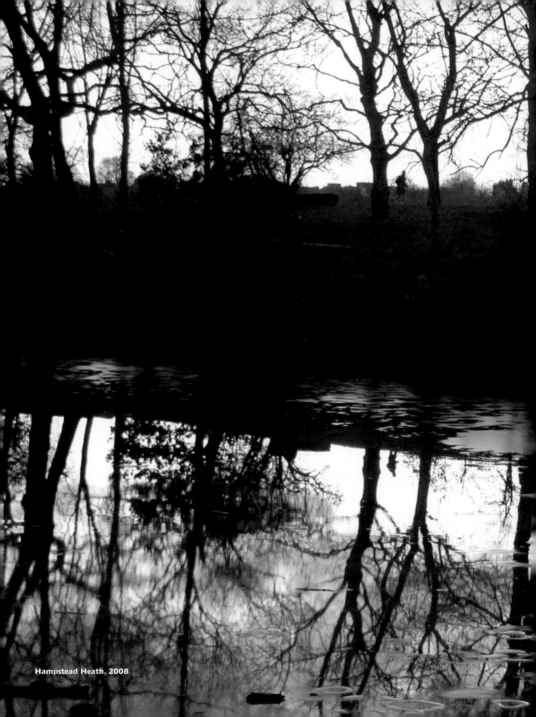

Hampstead Heath, 2008

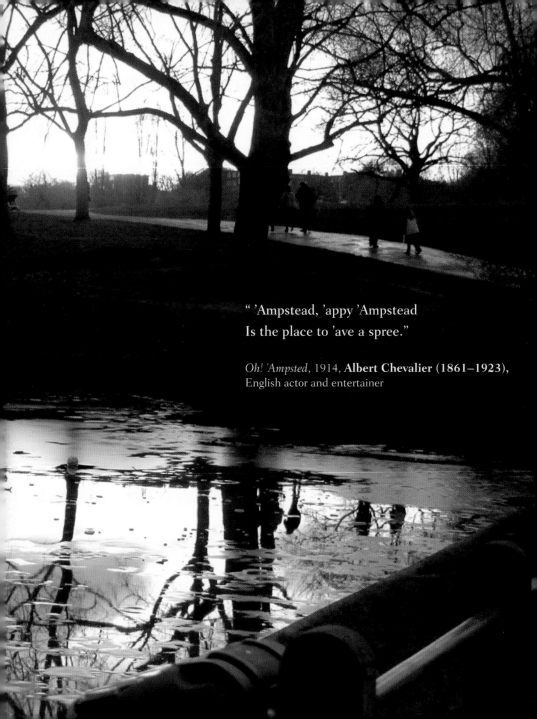

" 'Ampstead, 'appy 'Ampstead
Is the place to 'ave a spree."

Oh! 'Ampsted, 1914, **Albert Chevalier (1861–1923)**,
English actor and entertainer

From Centre Point, 2009

"A foggy day in London Town
Had me low and had me down."

From the musical *Damsel in Distress*, 1937,
Ira Gershwin (1896–1983),
American lyricist

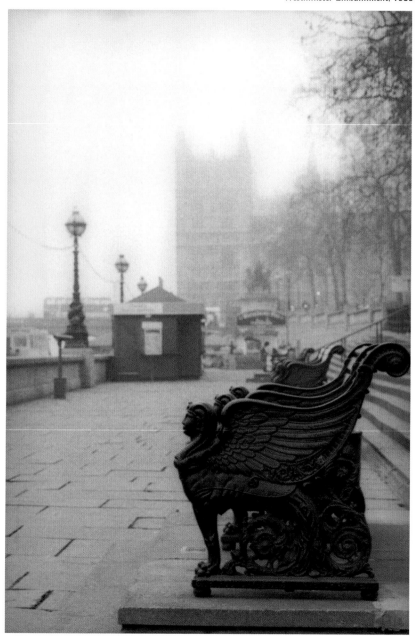

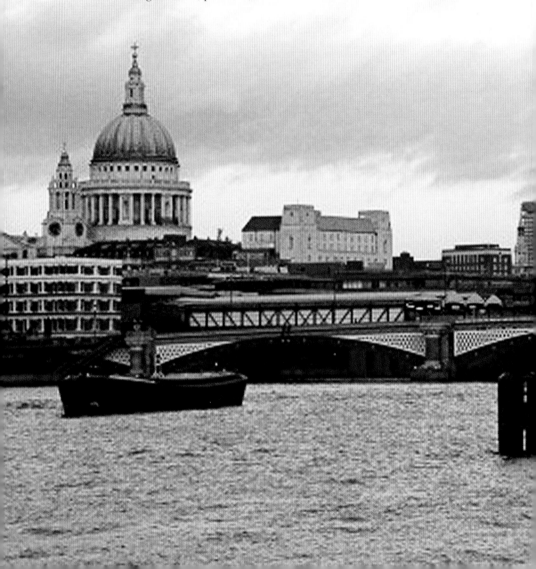

"No loveliness we see
In all the earth, but it abounds in thee."

Elegia Prima ad Carolum Diodatum, c1627 (translated by William Cowper), **John Milton (1608–1674),** English writer, poet and thinker

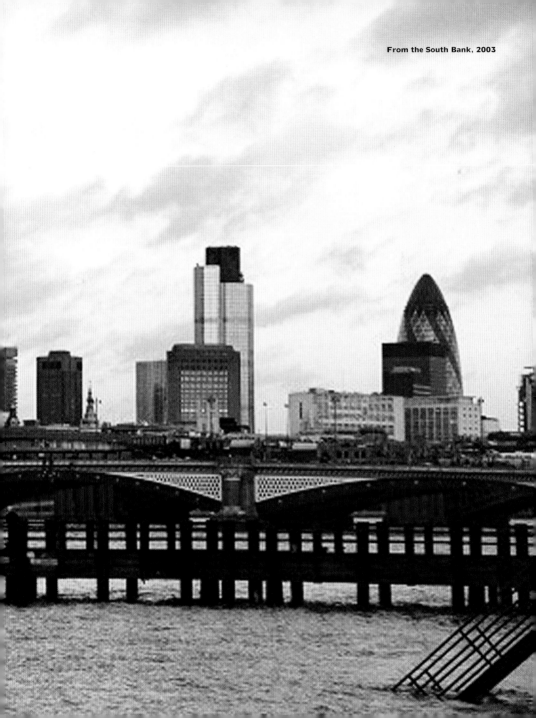
From the South Bank, 2003

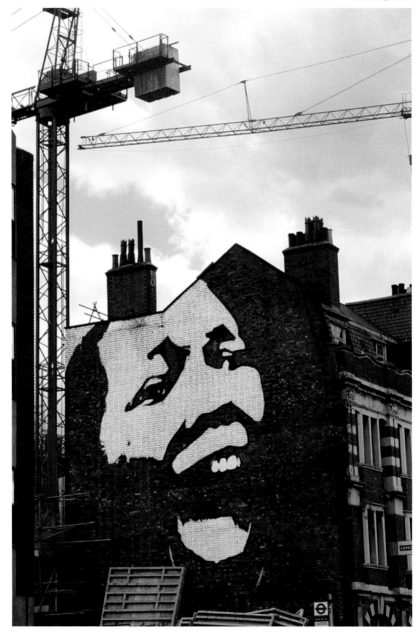

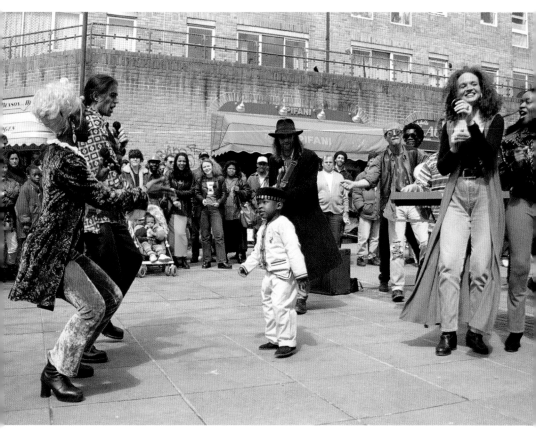

Portobello Road, 1996

"I love the multicultural make-up of the city …
the hip-hop culture and the alternative culture."

Benjamin Zephaniah (1958–),
British-Jamaican Rasta and performance poet

"By night or by day, whether noisy or silly,
Whatever my mood is, I love Piccadilly."

London Lyrics, 1857,
Frederick Locker-Lampson (1821–1895),
English poet

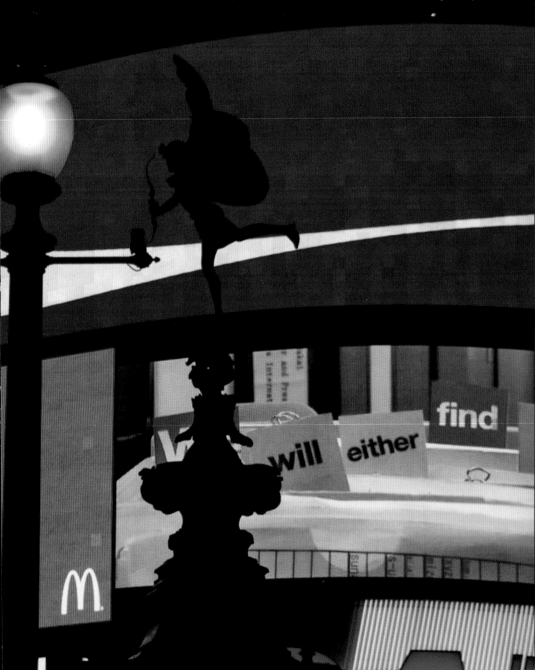

Statue of Eros, Piccadilly Circus, 1993

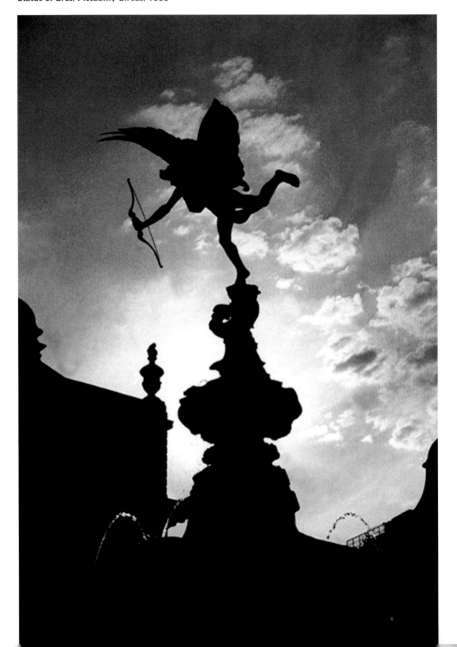

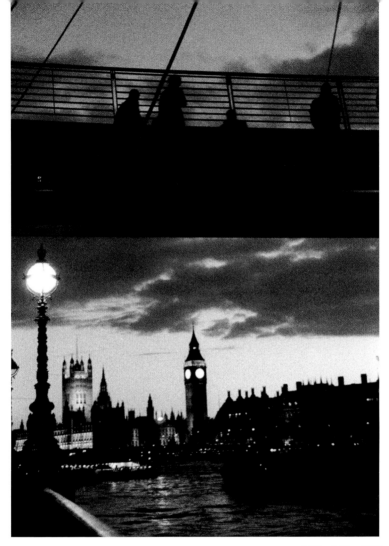

"This melancholy London – I sometimes imagine that the souls of the lost ... walk through its streets perpetually."

Letter, 1888, **W.B. Yeats (1865–1939)**,
Irish writer, dramatist and poet

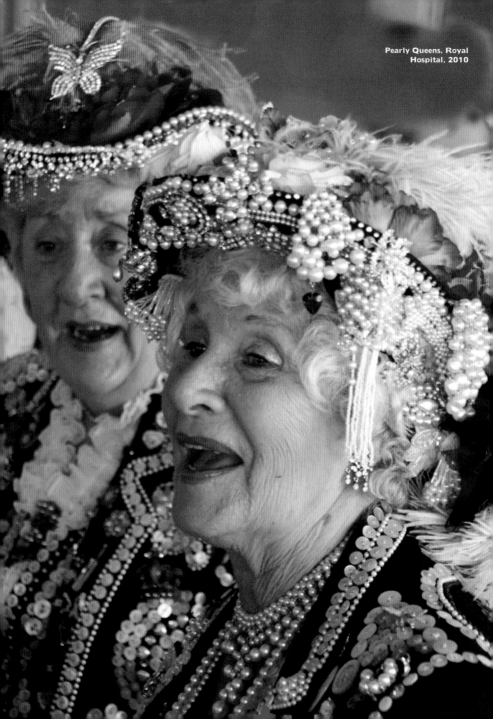

"The Pearly Kings and Queens was 'ere, they came to do us proud."

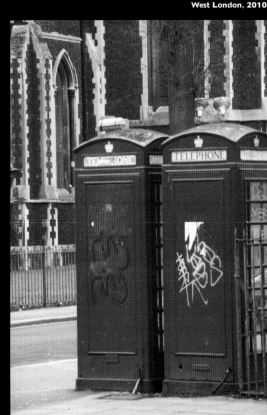

West London, 2010

"The Englishman's telephone box is his castle. Like the London taxi, it can be entered by a gentleman in a top hat. It protects the user's privacy, keeps him warm, and is a large enough for a small cocktail party."

International Herald Tribune, 1985, **Mary Blume,** American author and journalist

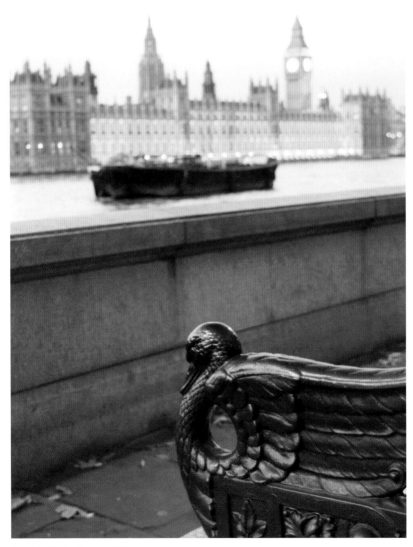

Lambeth Embankment, 2010

River Lea, 2010

"Their legs get wet,
Their tummies wetter:
I think after all
The bus is better."

Silly Verse for Kids, 1959, **Spike Milligan
(1918–2002),** Irish comedian, writer,
musician and poet

"London is enchanting. I step out upon
a tawny coloured magic carpet."

Diaries, 1915–1941, **Virginia Woolf (1882–1941),**
English writer

West London, 2010

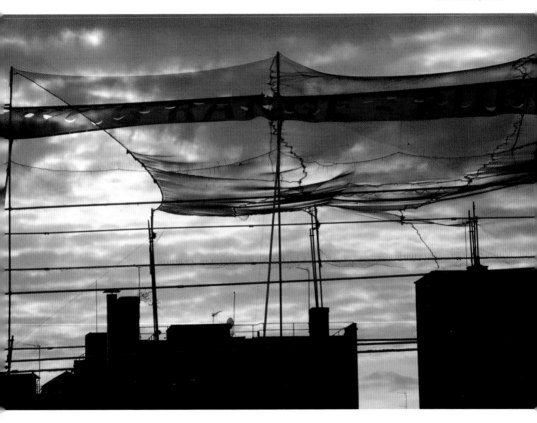

"The poor buildings lose themselves in the dim sky,
and the tall chimneys become campanili."

London, **James McNeill Whistler** (1834–1903),
American-born, British-based artist

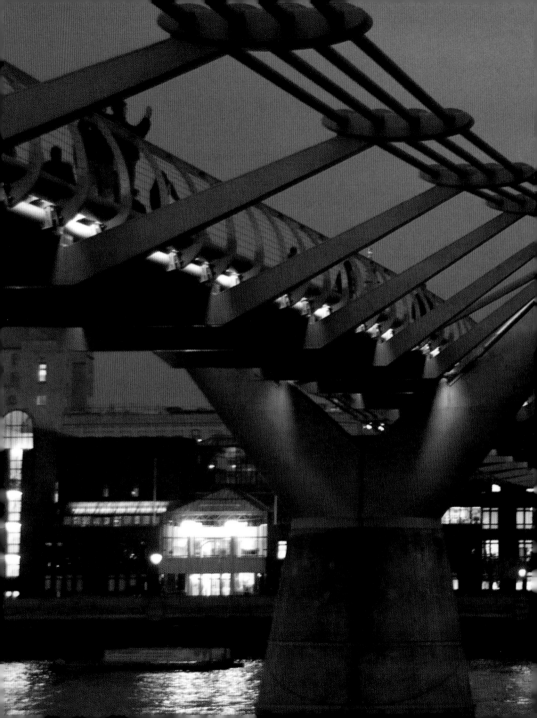

"I saw a solemn, orbed mass, dark-blue and dim – THE DOME … my spirit shook its always-fettered wings half loose."

Villette, 1853, **Charlotte Brontë (1816–1855)**, English novelist

Millennium Bridge and St Paul's, 2008

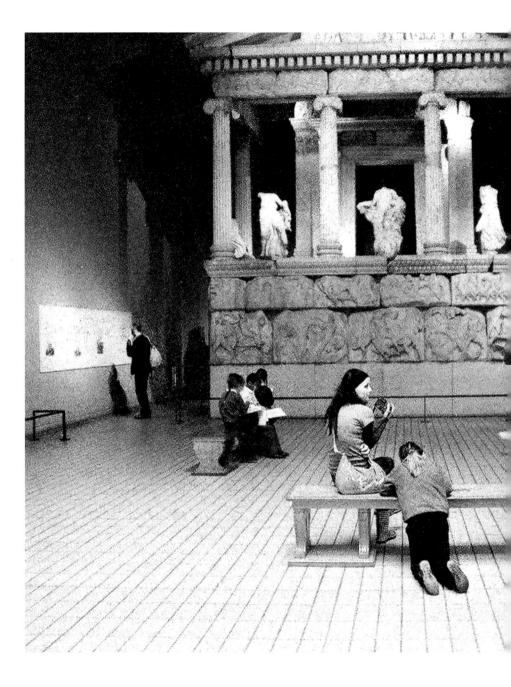

Highgate Cemetery, 2010

"If people don't like Marxism, they should blame the British Museum."

Mikhail Gorbachev (1931–), former leader of the Soviet Union

British Museum, 2009

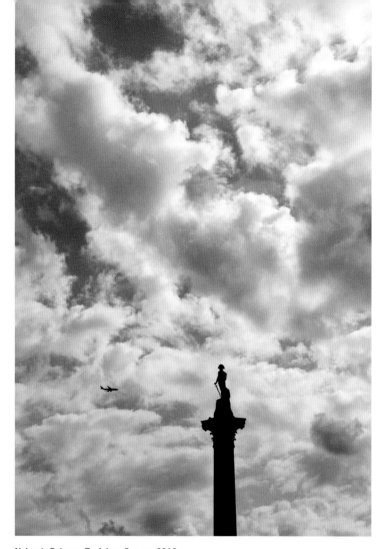

Nelson's Column, Trafalgar Square, 2010

"What's good enough for Nelson is good enough for us."

Musical Hall Tramp Song, *Memories*, 1919, **Lord Fisher (1841–1920),**
Admiral of the Fleet

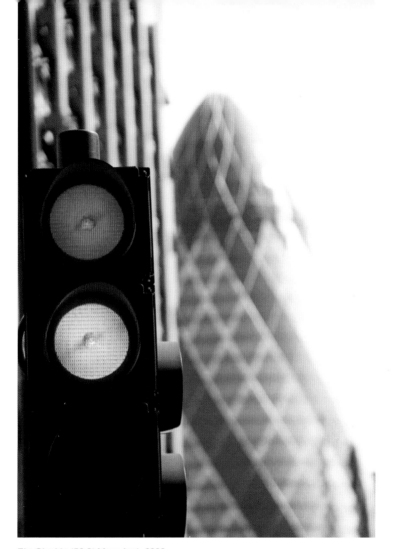

The Gherkin (30 St Mary Axe), 2009

"Such art thou! Mighty in thy power and pride
No city of the earth with thee can vie."

London, 1814, from *Memoirs of the Life of Sir Humphry Davy*, 1836,
Sir Humphrey Davy (1778–1829), English scientist

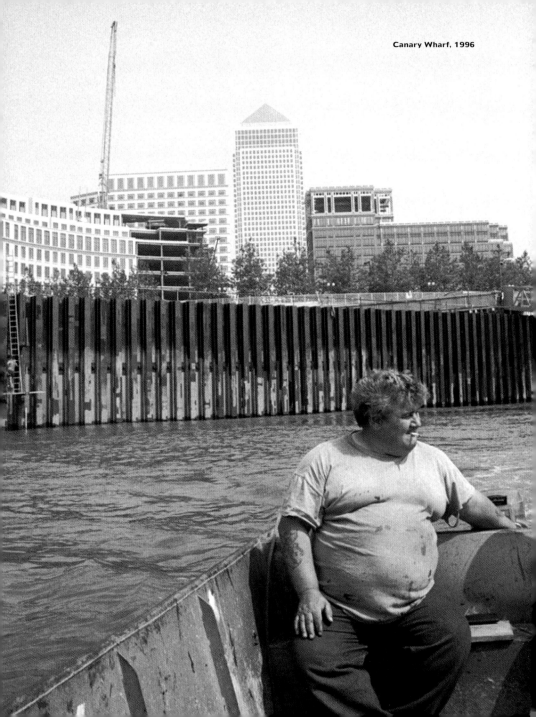

Canary Wharf, 1996

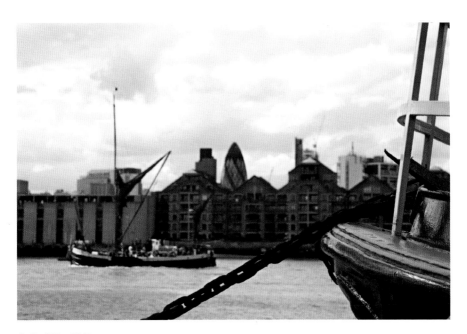

Rotherhithe, 2010

"Thou Thames, I say, where barge
and boat doth ride."

*The Lover to the Thames of London to
Favour His Lady,* **George Turberville
(1821–1873),** English poet

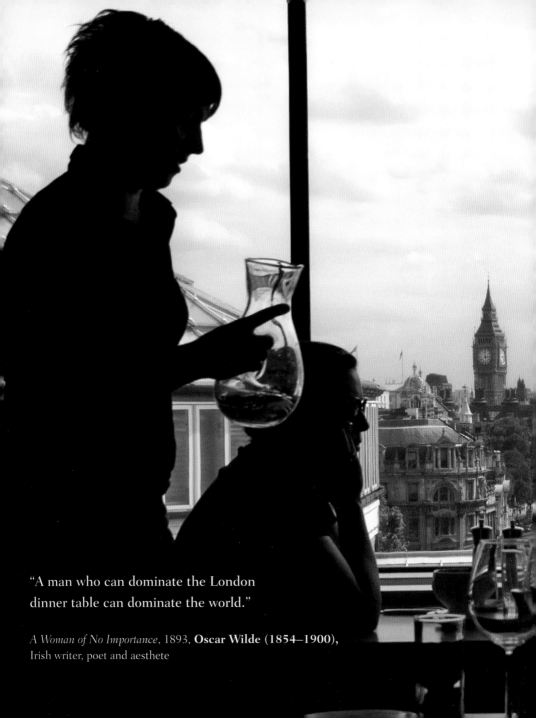

"A man who can dominate the London dinner table can dominate the world."

A Woman of No Importance, 1893, **Oscar Wilde (1854–1900),**
Irish writer, poet and aesthete

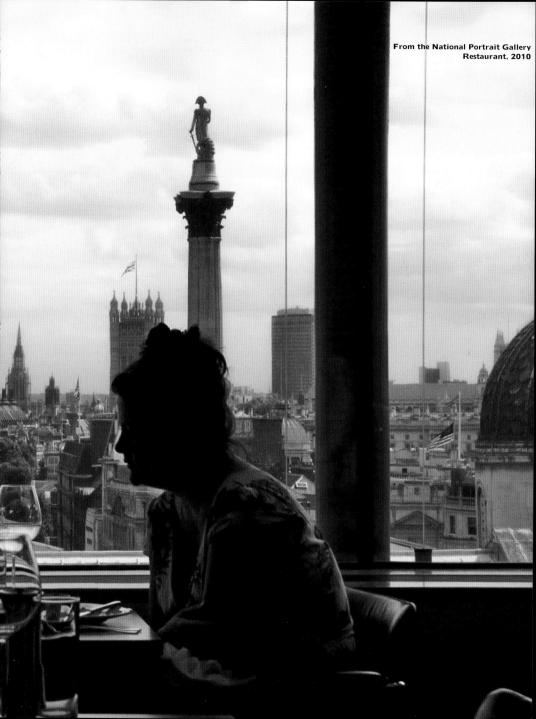

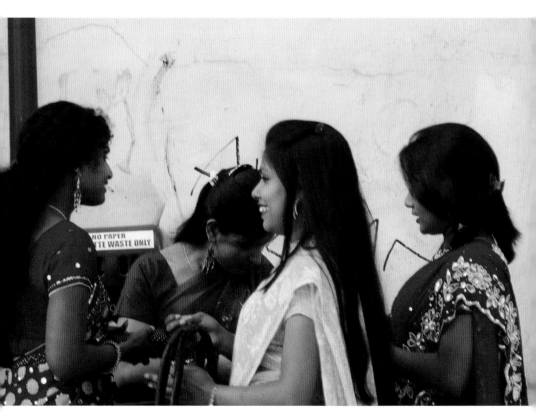

"The English girls are divinely pretty."

On England, c1499,
Desiderius Erasmus (c1466–1536),
Dutch humanist, scholar, priest and theologian

London Underground, 2009

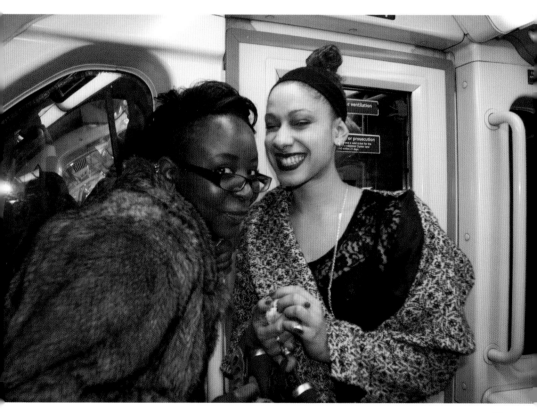

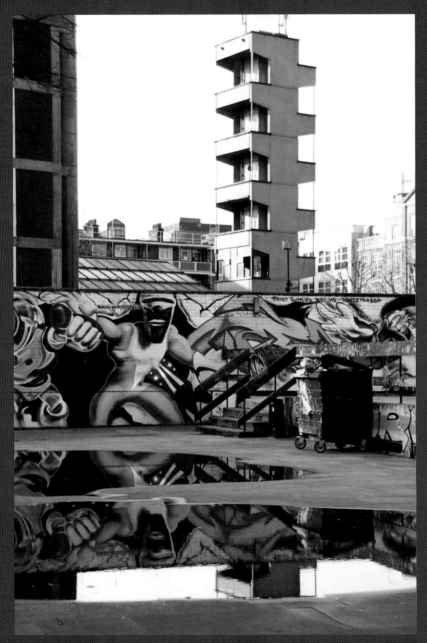

Old Street, 2010

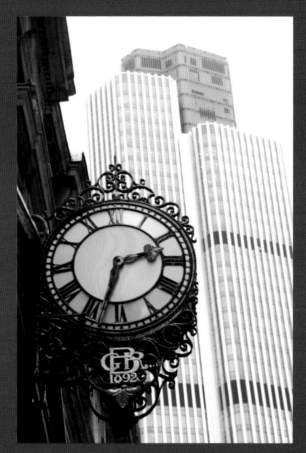

Tower 42 from Throgmorton Street, 2009

"The higher the buildings, the lower the morals."

Noël Coward (1899–1973),
British writer, composer, director, actor and singer

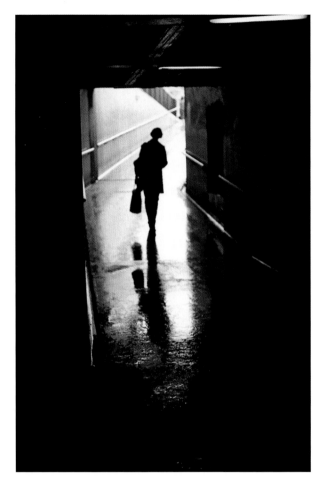

Hyde Park underpass, 1987

"… it was a good place for getting lost in,
a city no-one ever knew."

An Area of Darkness, 1964, **V.S. Naipul (1932–),**
Trinidadian writer of Indian descent

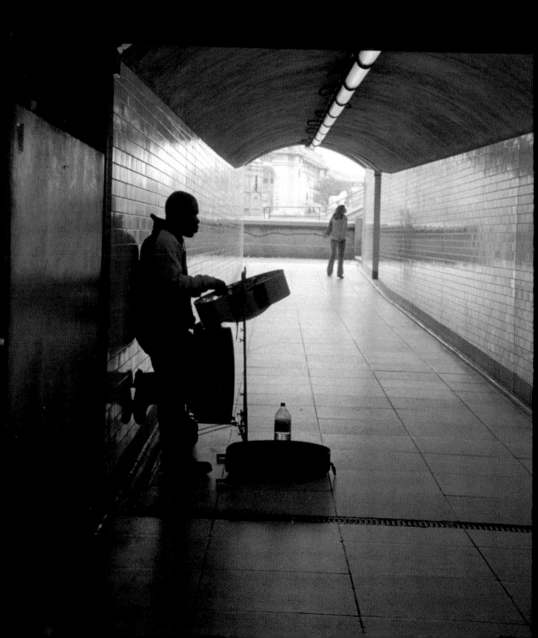

Leicester Square, 2009

"The sun fell on a scene red, white and black;
for those are the colours of London."

In Search of London, 1951, **H.V. Morton (1892–1979),**
British writer and journalist

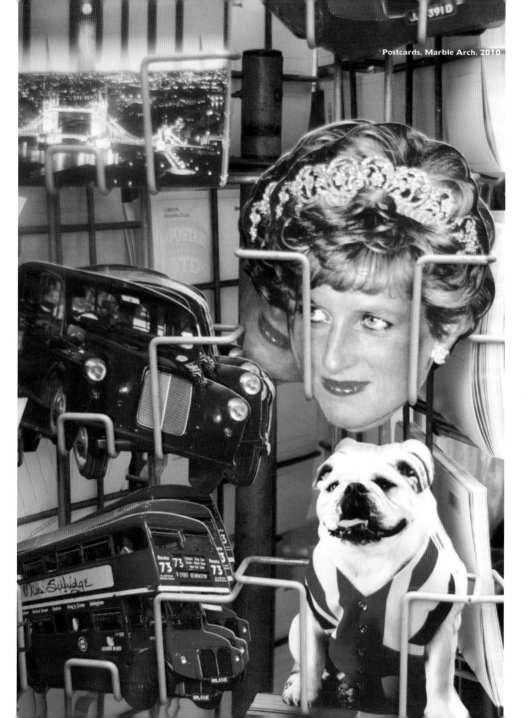

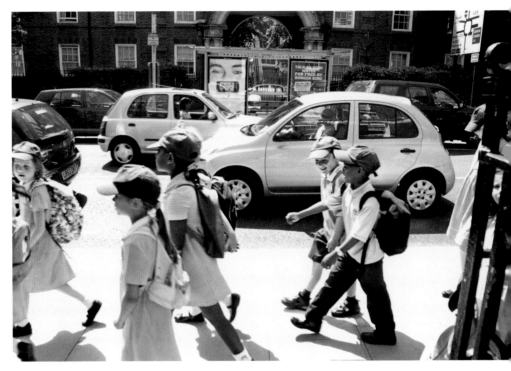

Hammersmith, 2010

"... their innocent faces clean
The children walking two and two,
in red and blue and green."

Songs of Innocence, 1789,
William Blake (1757–1827),
English poet, artist and visionary

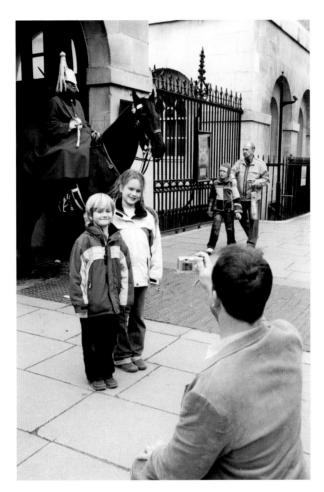

Whitehall, 2009

"Yankee Doodle came to London,
just to ride the ponies."

Little Johnny Jones, 1904,
George M. Cohan (1878–1942),
American songwriter

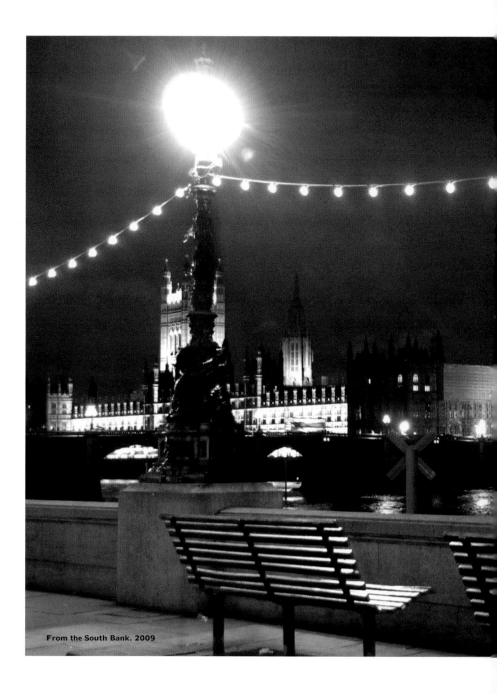

From the South Bank, 2009

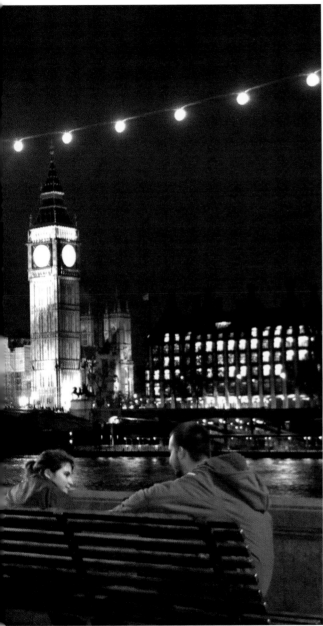

The London Eye at night, 2010

"O gleaming lights of London, that gem of the city's crown, What fortunes be within you, O Lights of London Town!"

Lights of London, 1881,
**George Robert Sims
(1847–1922),**
English writer

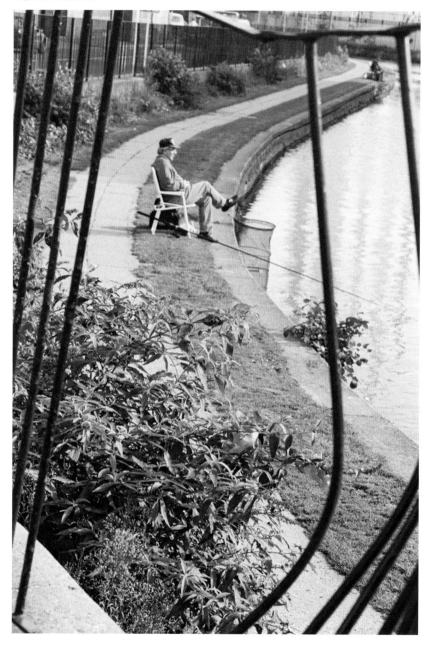

Regent's Canal, 1999

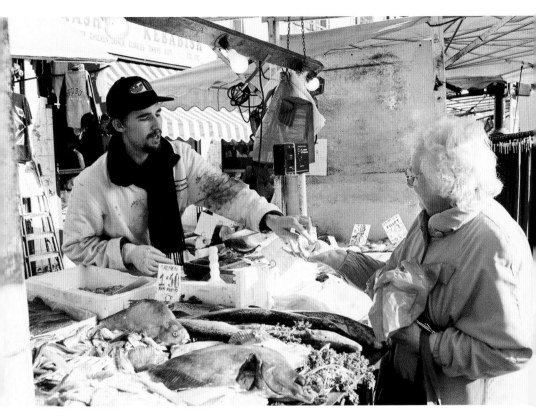

Ridley Road market, 1998

"She [London] is just like a vast ocean where
sardines as well as whales are living together."

A Japanese Artist in London, 1910,
Yoshio Markino (1869–1956),
Japanese artist and writer

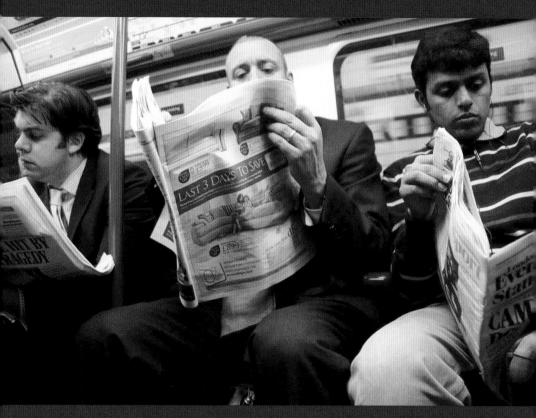

The London Underground, 2010

"If Britons sit in trains or buses without striking up
conversations with you, it doesn't mean they are
being haughty or unfriendly."

Instructions for American Servicemen in Britain, 1942,
War Department, Washington DC

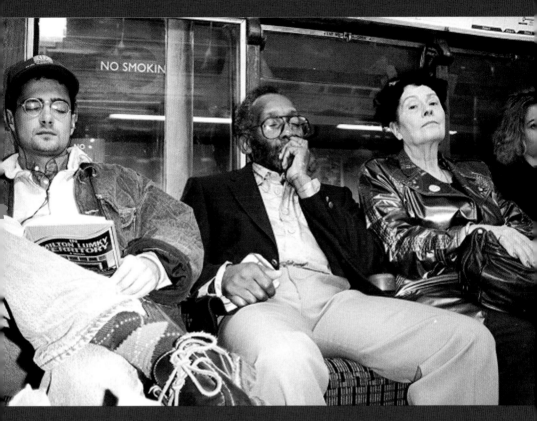

The London Underground, 1993

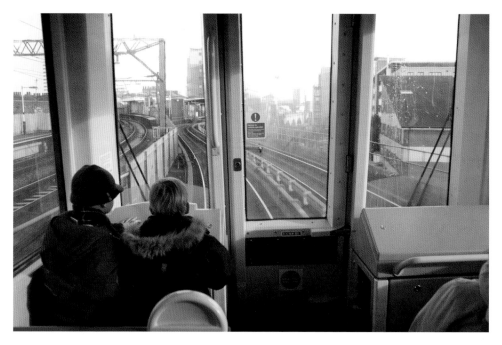

Docklands Light Railway, 2010

"At length they all to merry London came."

Prothalamion, 1596,
Edmund Spenser (c1552–1599),
English poet

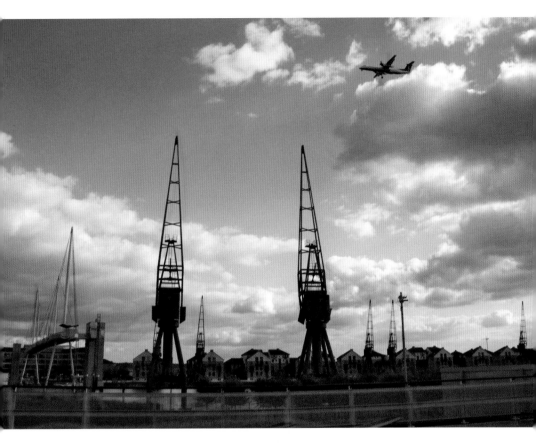

Royal Victoria Dock, 2009

"One feels an important, a complex, a necessary animal as one stands on the quayside watching the cranes."

London Scene, 1934,
Virginia Woolf (1882–1941),
English writer

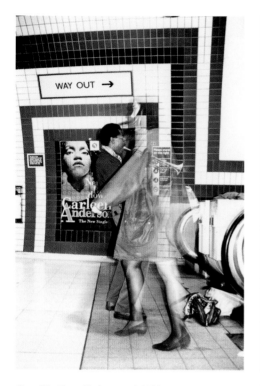

Piccadilly Circus Underground, 1996

The South Bank, 1992

"The English may not like music, but they absolutely love the noise it makes."

Sir Thomas Beecham (1879–1961),
British conductor and impresario

Portobello Road, 1995

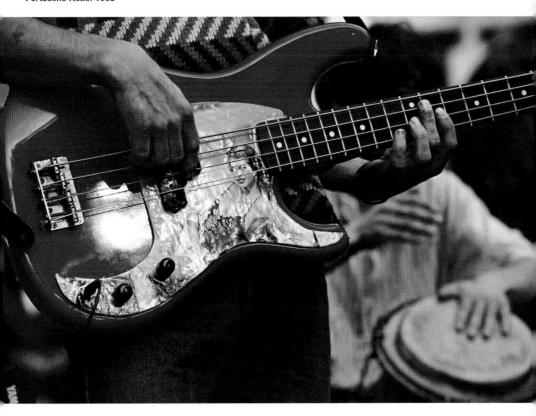

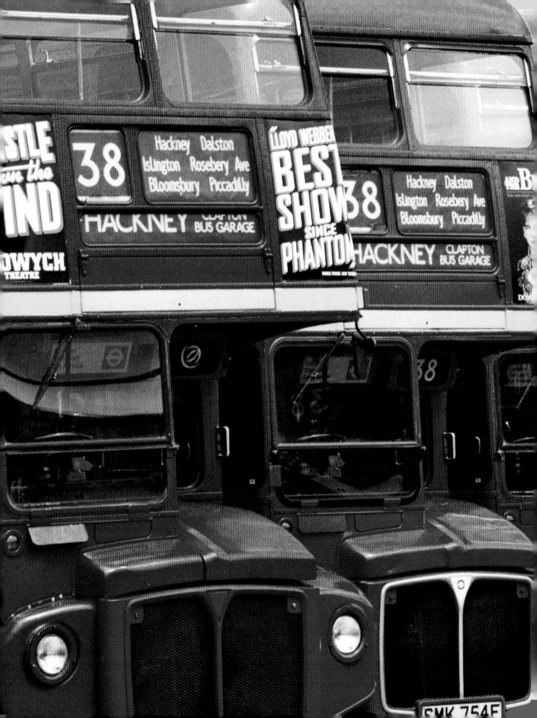

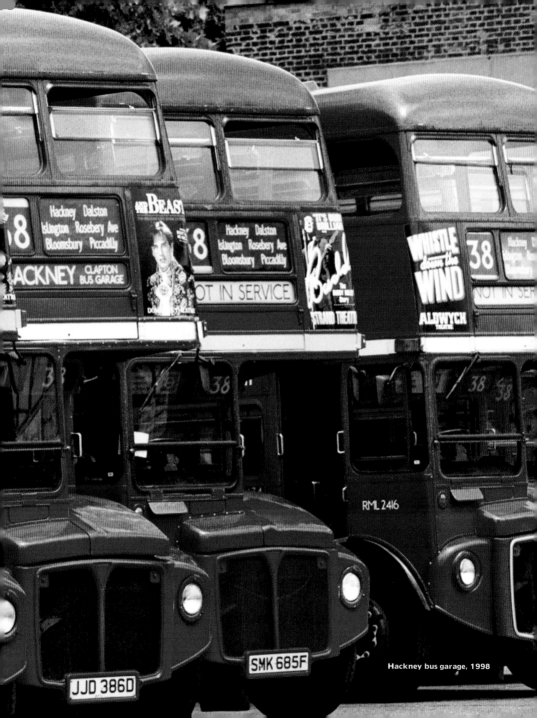

Hackney bus garage, 1998

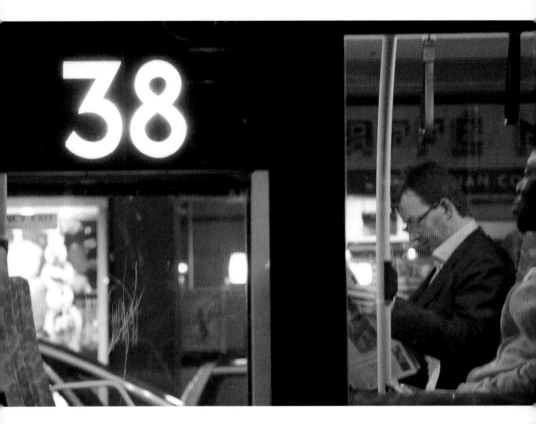

Piccadilly, 2009

"Earth has not anything to show more fair!
Any more fares? Any more fares?"

A Transport of Delight (The Omnibus), 1952,
Michael Flanders (1922–1975), British lyricist

"How often my Soul visits the National Gallery, and how seldom I go there myself."

Afterthought, 1931,
Logan Pearsall Smith (1865–1946),
American-born British essayist and critic

National Gallery, 2011

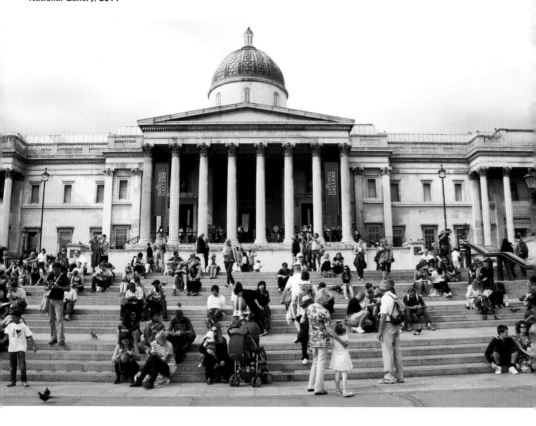

Hyde Park, 2010

"I think London's sexy because it's full of eccentrics."

Index Magazine, 2010, **Rachel Weisz (1970–),**
English actress

Notting Hill Carnival, 1996

Shoreditch, 2010

"A good old British sense of HUMOUR.
With a U right? Not HUMOR, gottit?"

Boris Johnson (1964–),
Mayor of London since 2008

Shoreditch, 2010

"Let's all go down the Strand — have a banana!
Oh! What a happy land."

Let's All Go Down the Strand, 1904,
Harry Castling (1865–1933) and C.W. Murphy (1875–1913),
lyricists

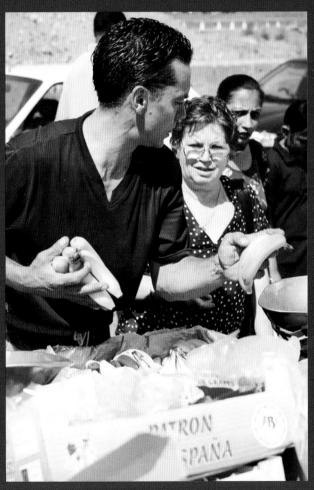

Hackney, 1999

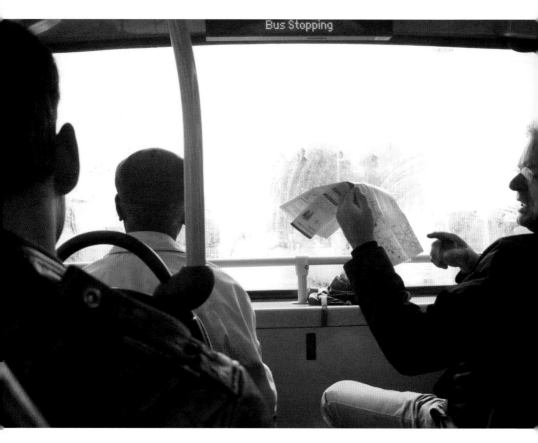

London bus, 2010

"London is far more difficult to see properly than any other place."

All Things Considered, 1908,
G.K. Chesterton (1874–1936),
English writer

Oxford Street, 2010

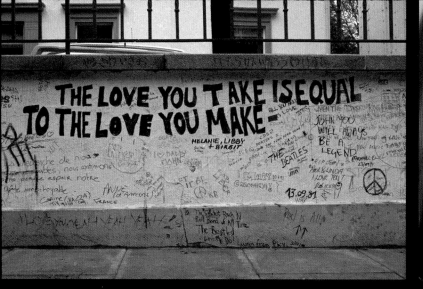

THE LOVE YOU TAKE IS EQUAL
TO THE LOVE YOU MAKE —

Abbey Road, 1992

"Well I've never been to England
But I kind of like the Beatles."

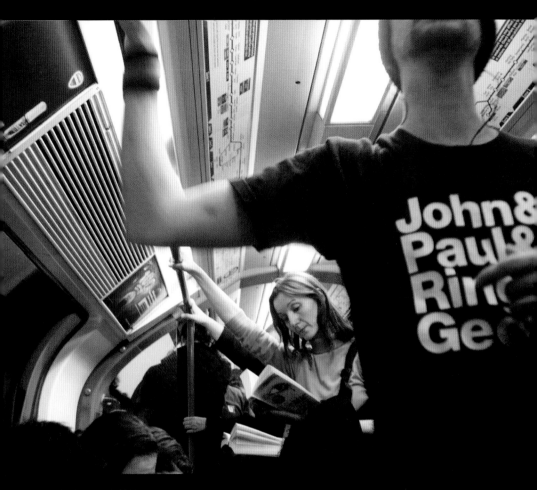

London Underground, 2009

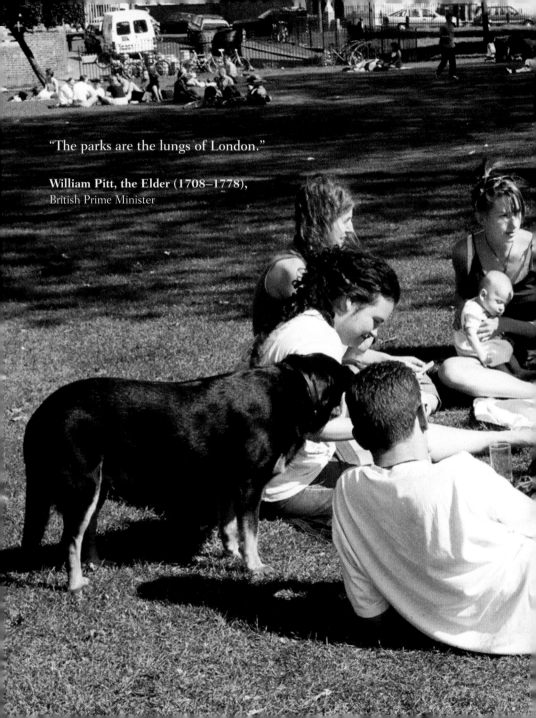

"The parks are the lungs of London."

William Pitt, the Elder (1708–1778),
British Prime Minister

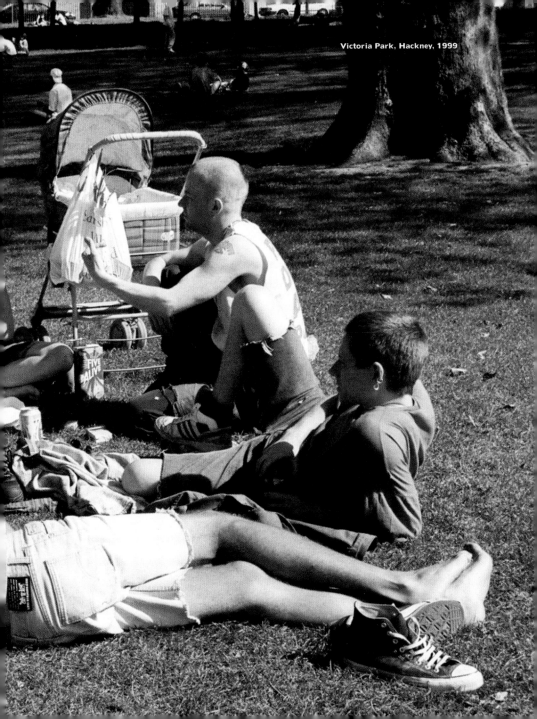

Victoria Park, Hackney, 1999

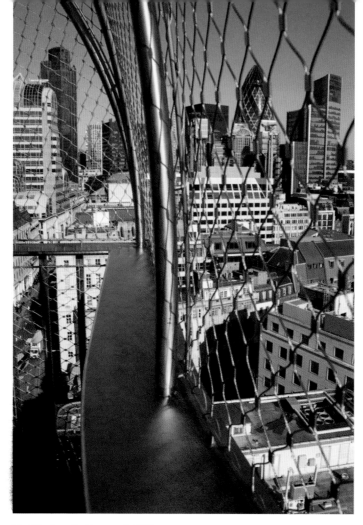

The City from the Monument, 2010

"Where all that gaz'd were so amaz'd
At such a furious flame."

Traditional 17th Century ballad, *London Mourning in
Ashes*, 1666, after the Great Fire of London, **Anon.**

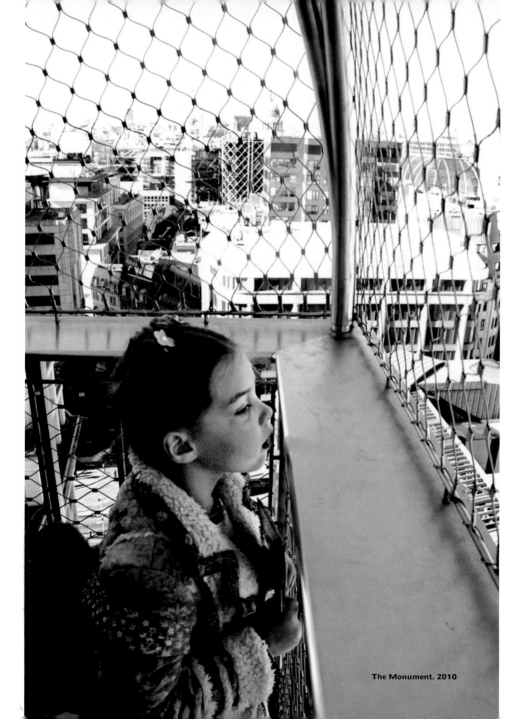

The Monument, 2010

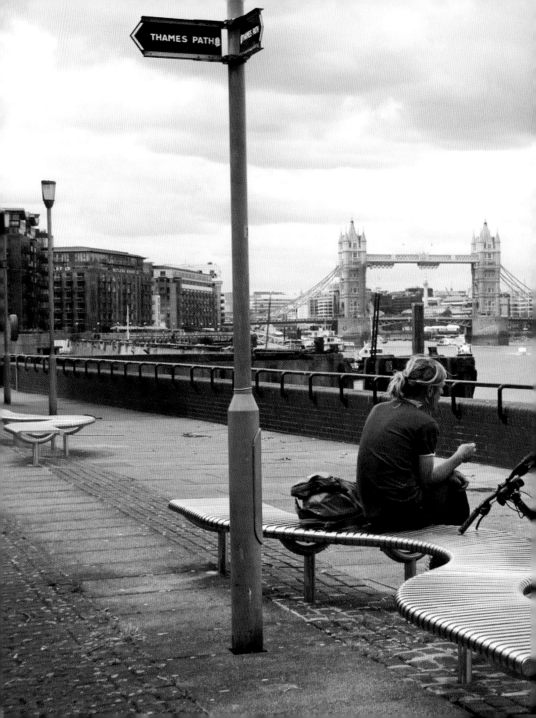

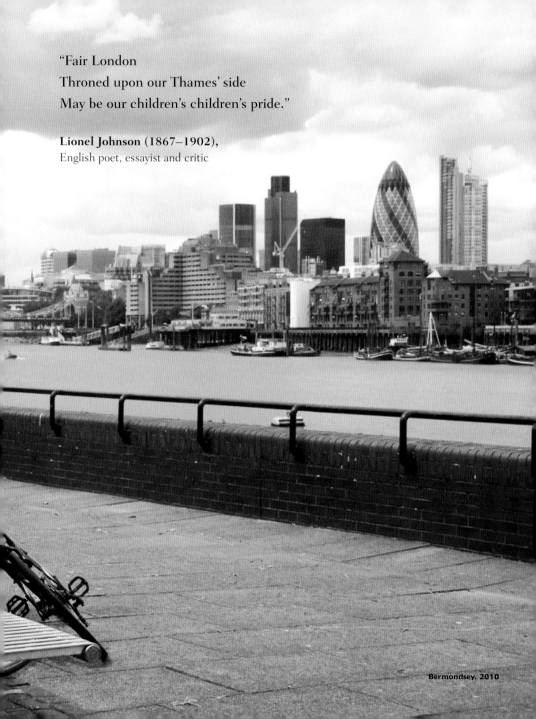

"Fair London
Throned upon our Thames' side
May be our children's children's pride."

Lionel Johnson (1867–1902),
English poet, essayist and critic

Bermondsey, 2010

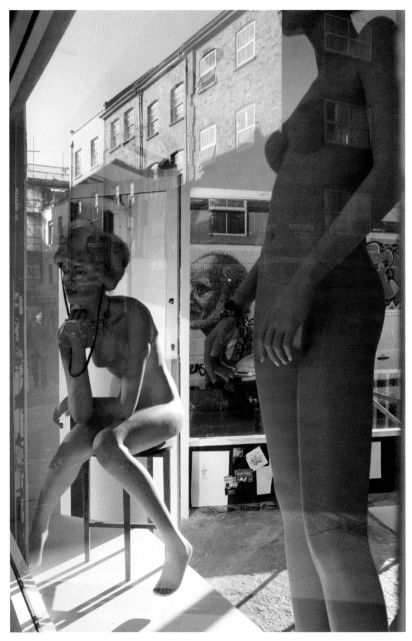

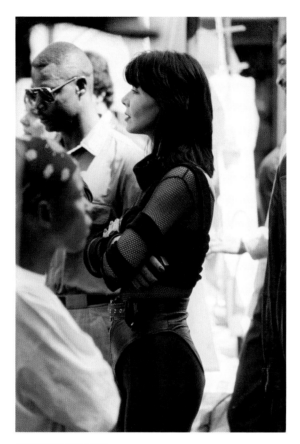

Portobello Road, 1995

"When I walk along High Holborn
I think of you with nothing on."

Celia Celia, 1968,
Adrian Mitchell (1932–2008),
English poet

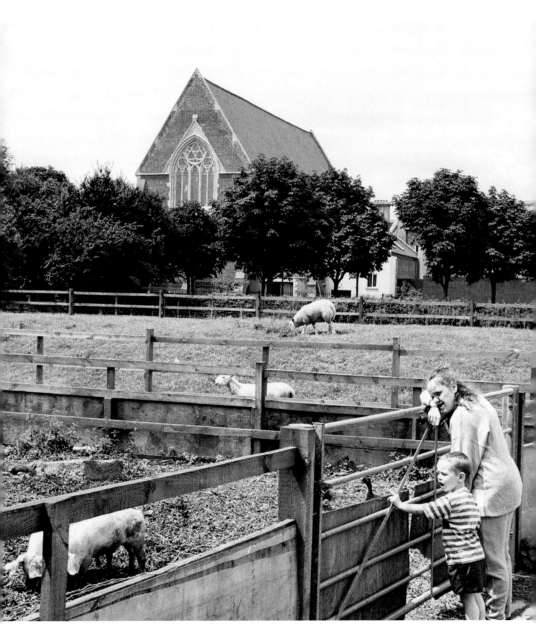

Hackney City Farm, 1999

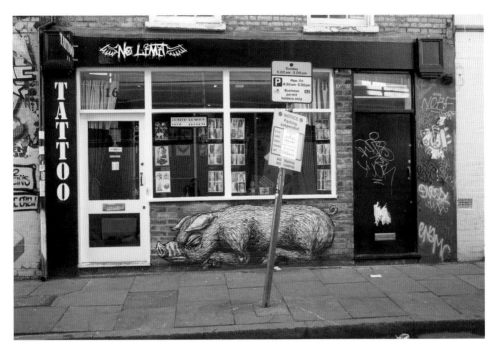

Off Brick Lane, 2010

" 'Til the whinny of a horse arose
From some near-by urban farm ...
A stone's throw from Brick Lane."

Shoreditch, 1998, **Alan Gilbey (1958–),**
British poet, script writer and performance artist

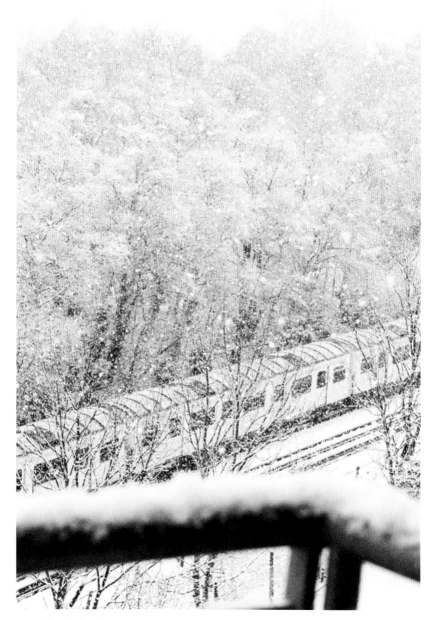

Gunnersbury Triangle, 2007

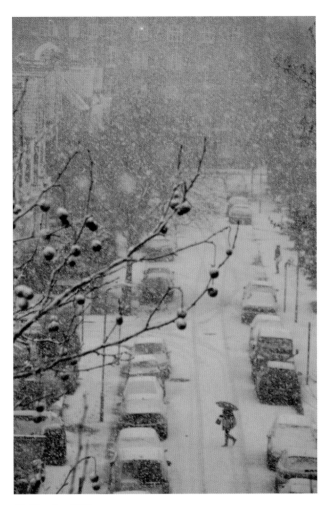

West London, 2009

"Silently sifting and veiling road, roof and railing."

London Snow, 1890,
Robert Bridges (1844–1930),
English poet

Camden, 2010

West Ealing, 2010

"The English contribution
to world cuisine – the chip."

John Cleese (1939–),
British actor, writer and
film producer

133

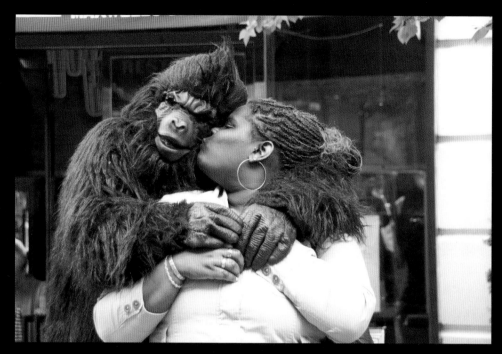

Covent Garden, 2009

"All of London littered with remembered kisses."

Autumn Journal, Part IV, 1939,
Louis MacNeice (1907–1963),
Irish poet and playwright

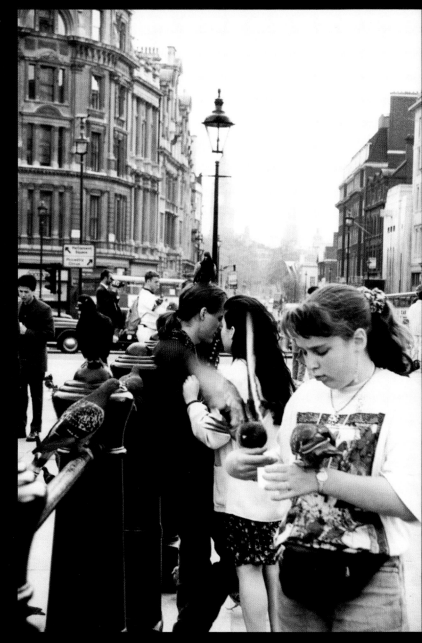

Trafalgar Square, 1991

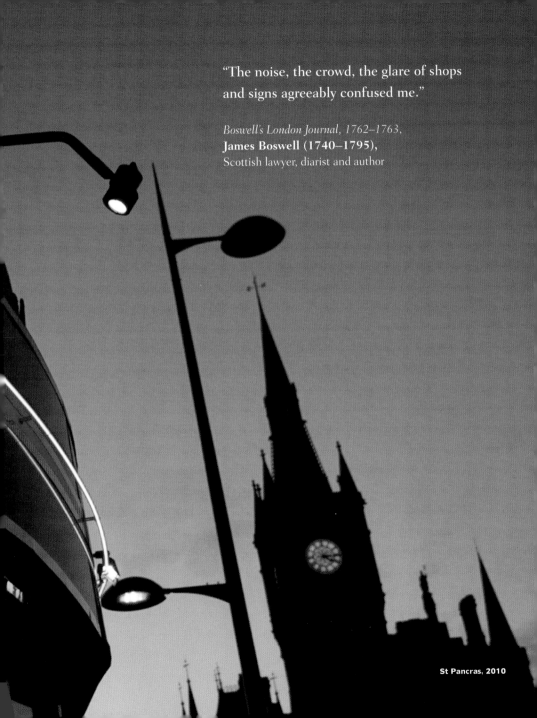

"The noise, the crowd, the glare of shops and signs agreeably confused me."

Boswell's London Journal, 1762–1763,
James Boswell (1740–1795),
Scottish lawyer, diarist and author

St Pancras, 2010

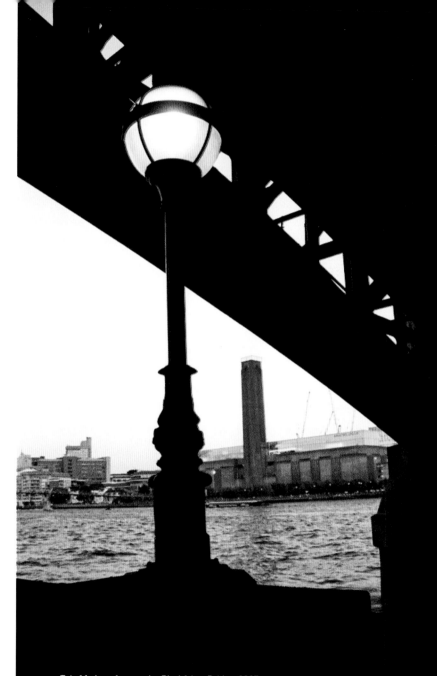

Tate Modern, from under Blackfriars Bridge, 2007

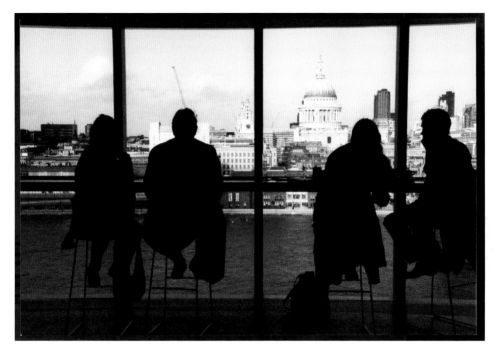

From Tate Modern to St Paul's Cathedral, 2005

"When a man is tired of London, he is tired of life."

Samuel Johnson (1709–1784),
English writer and lexicographer

The Gherkin from Brick Lane, 2008

"I see London, blind and age bent,
begging thro' the streets."

Jerusalem, 1804, **William Blake (1757–1827)**,
English poet, artist and visionary

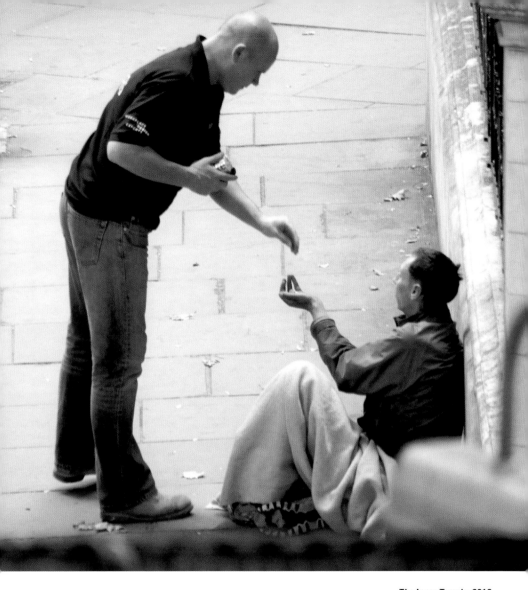

The Inner Temple, 2010

141

ICA Café, the Mall, 2009

"[In London] love and scandal are the best sweeteners of tea."

Love in Several Masques, 1728, **Henry Fielding (1707–1754),** English novelist and dramatist

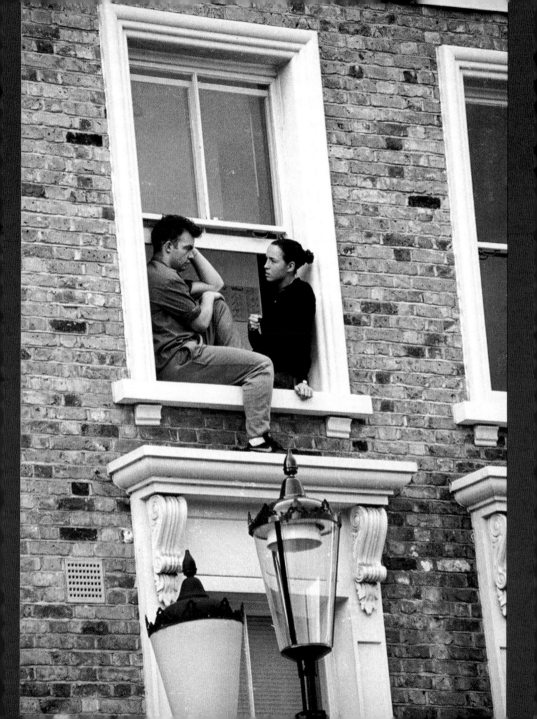

Tower Bridge, 1998

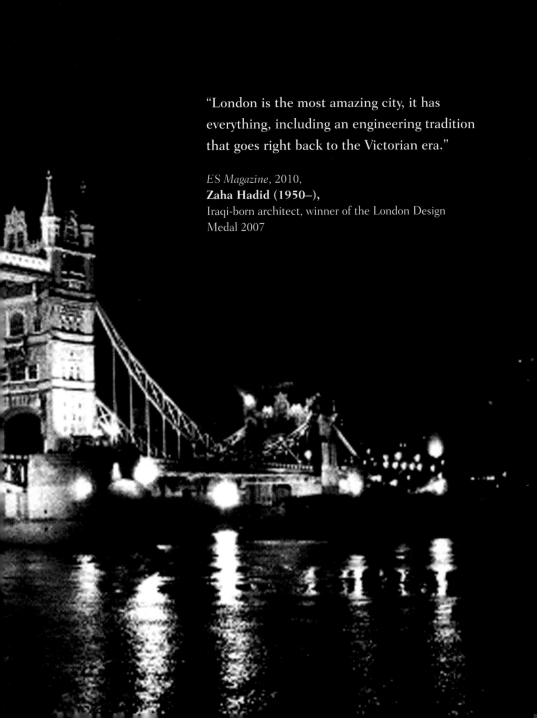

"London is the most amazing city, it has everything, including an engineering tradition that goes right back to the Victorian era."

ES Magazine, 2010,
Zaha Hadid (1950–),
Iraqi-born architect, winner of the London Design Medal 2007

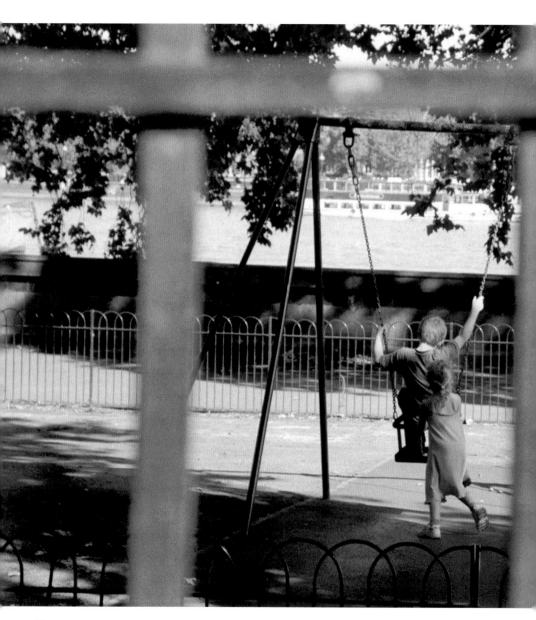

Victoria Embankment, 2006

"London is the only place in which the child grows completely up into the man."

Essay on Londoners and Country People, 1826,
William Hazlitt (1778–1830),
English literary critic and essayist

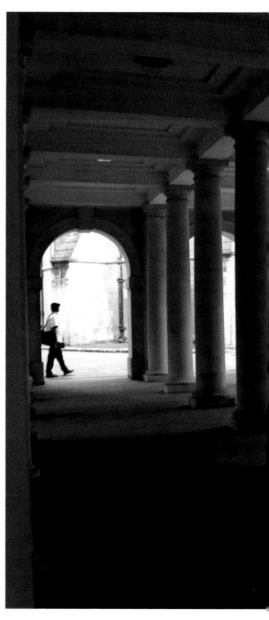

"My counsel sends to execute a Deed."

Imitations of Horace, 1737,
Alexander Pope (1688–1744),
English poet

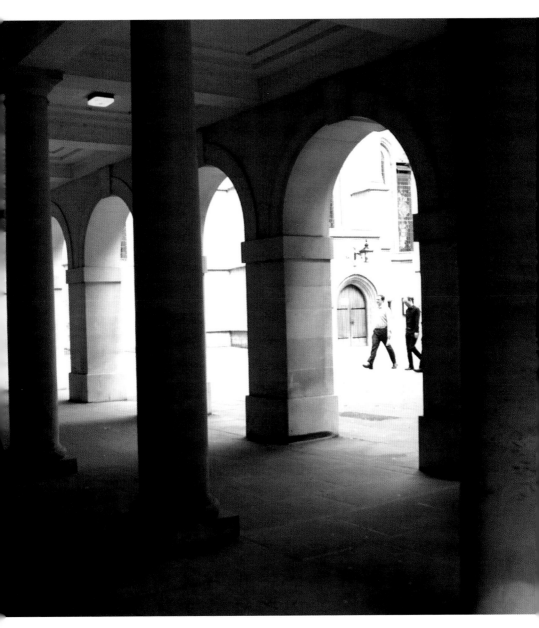

The Inner Temple, 2010

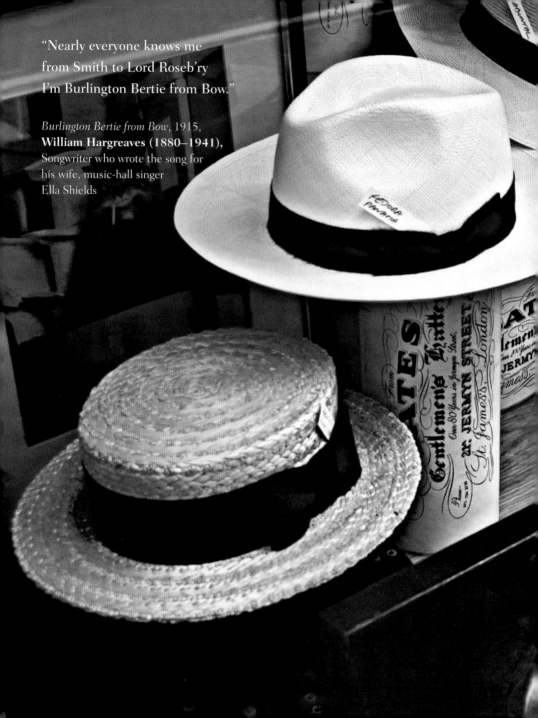

"Nearly everyone knows me
from Smith to Lord Roseb'ry
I'm Burlington Bertie from Bow."

Burlington Bertie from Bow, 1915,
William Hargreaves (1880–1941),
Songwriter who wrote the song for
his wife, music-hall singer
Ella Shields

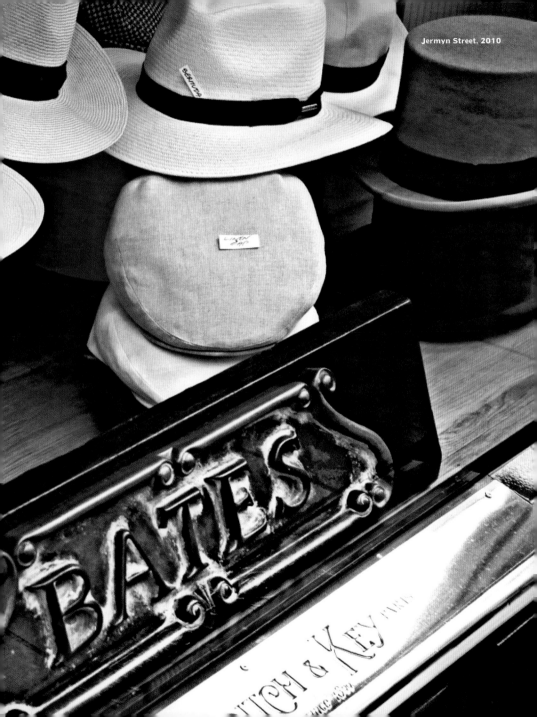

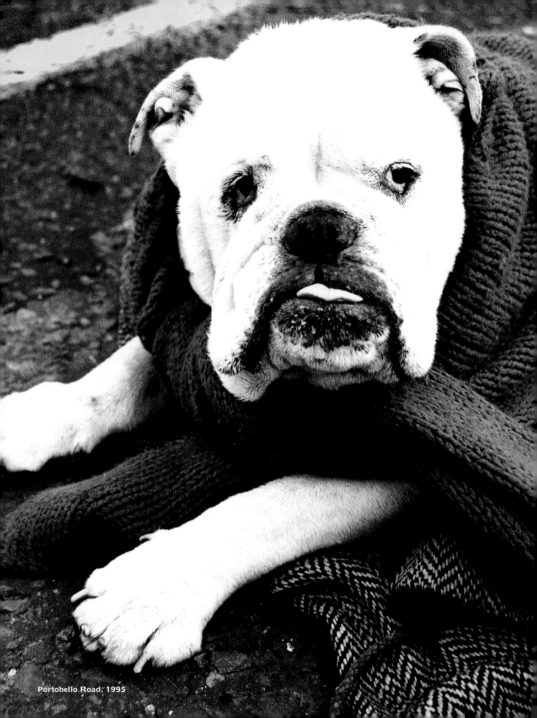

Portobello Road, 1995

Shoreditch, 2010

"I am his Highness' Dog at Kew;
Pray tell me Sir, whose Dog are you?"

*Epigram Engraved on the Collar of Dog
Which I Gave to His Royal Highness*, 1737,
Alexander Pope (1688–1744),
English poet

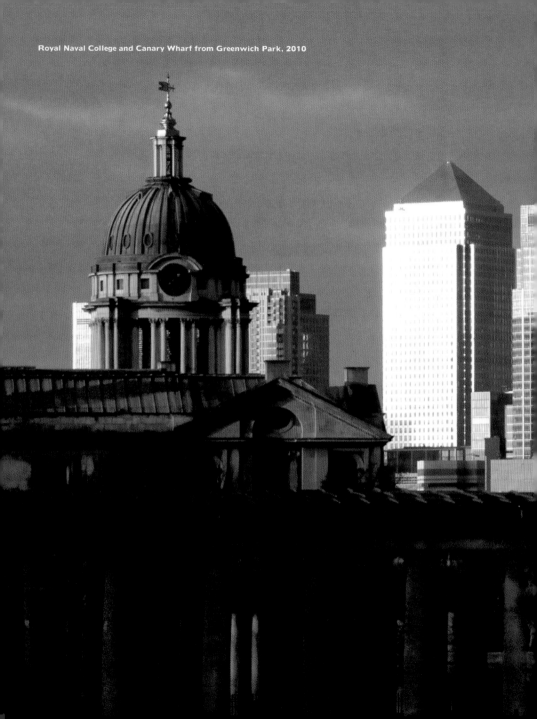

Royal Naval College and Canary Wharf from Greenwich Park, 2010

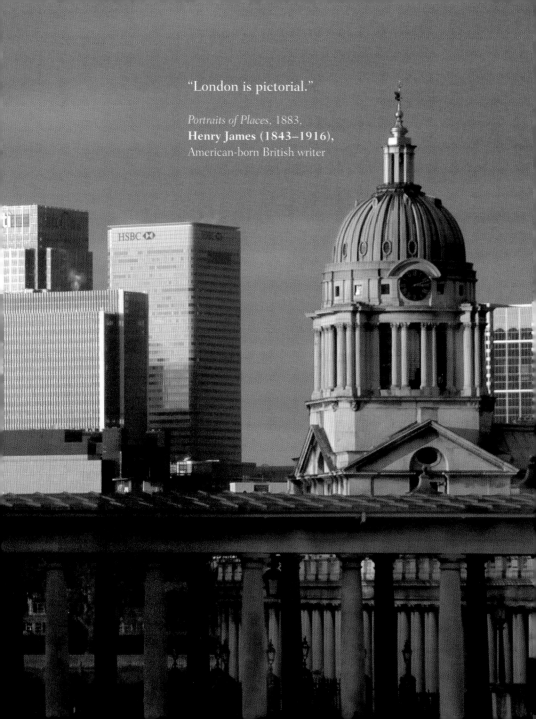

"London is pictorial."

Portraits of Places, 1883,
Henry James (1843–1916),
American-born British writer

Big Ben, 2008

"[The bells] ... are playing 'So hour by hour be Thou my Guide, That by Thy power, no step may slide'."

In Search of London, 1951, **H.V. Morton (1892–1979)**, British journalist and writer

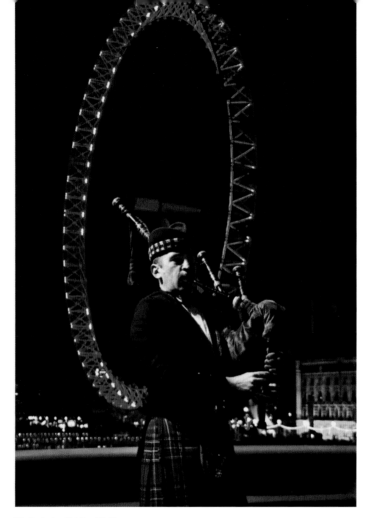

Westminster Bridge, 2010

"The highroads of a nation converge at Westminster, from Cromarty, from County Down, and misty Bodmin."

Byways of Westminster, 2001, **James Dowsing (1939–)**, British writer

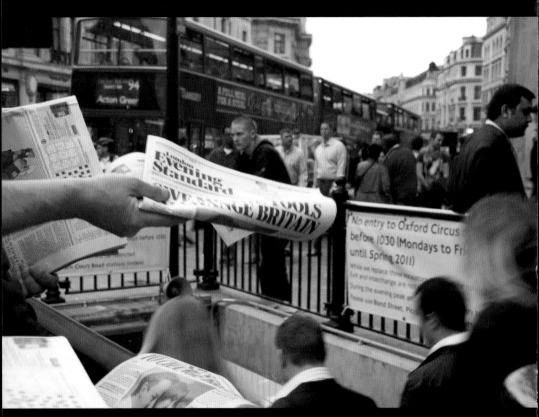

Oxford Circus, 2010

There's such a power of people, going
hurry skurry!"

The Expedition of Humphry Clinker, 1771.
Tobias Smollett (1721–1771),
Scottish poet and author

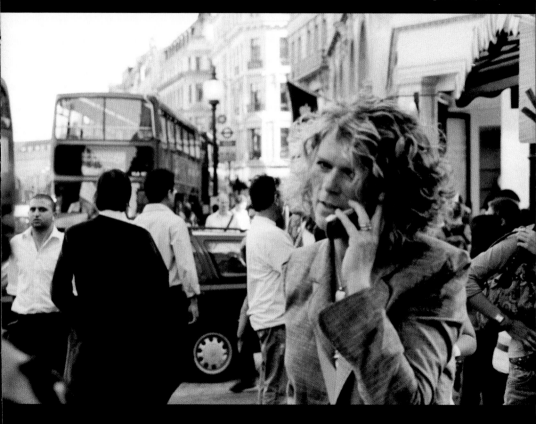

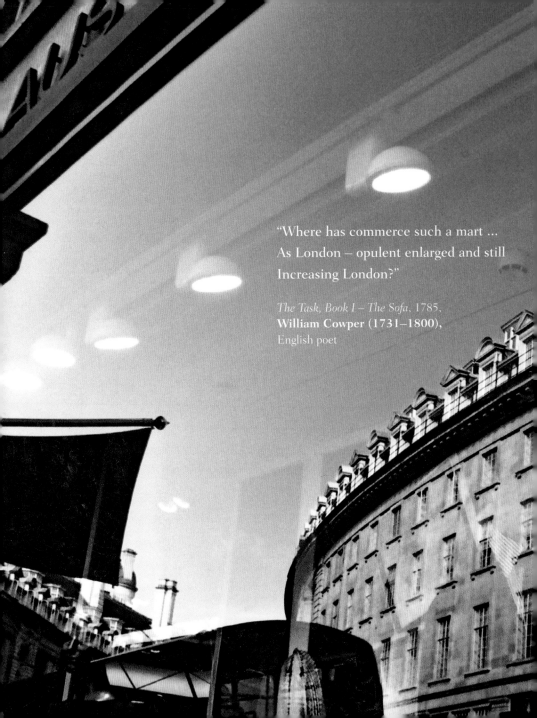

"Where has commerce such a mart ...
As London – opulent enlarged and still
Increasing London?"

The Task, Book I – The Sofa, 1785,
William Cowper (1731–1800),
English poet

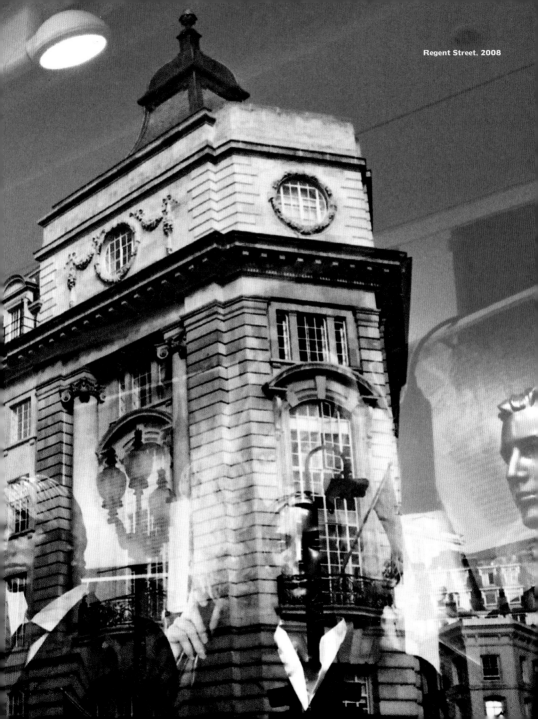

Regent Street, 2008

"O sweetheart, see! How shadowy ..."

London, **John Davidson (1857–1909),**
Scottish writer

"And every visitor that rolls
In restless coach from Mall to Paul's."

Ballad, 1718,
Anne Finch (1661–1720),
English poet

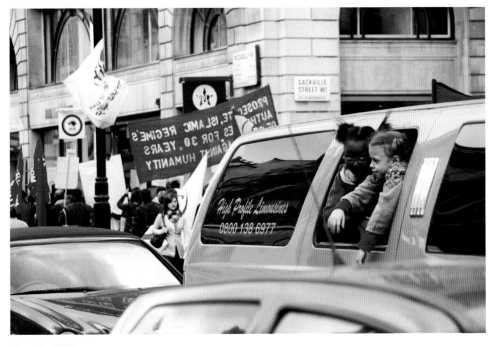

Piccadilly, 2010

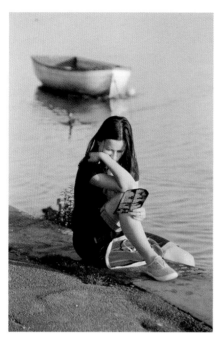

Strand-on-the-Green, 2009

"You may be alone and in Company at the same time."

Tom Jones, 1749,
Henry Fielding (1707–1754),
English novelist and dramatist

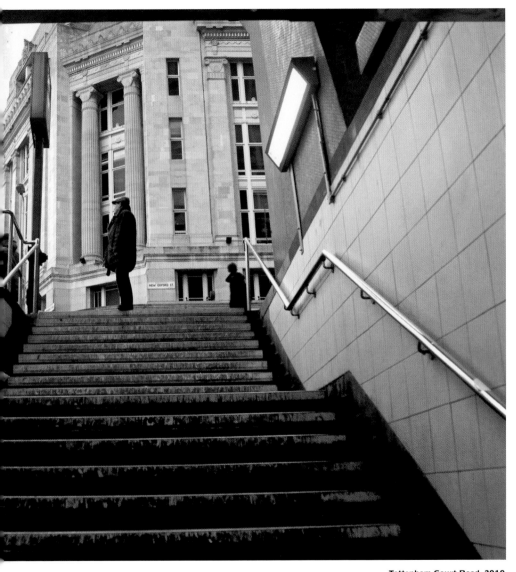

Tottenham Court Road, 2010

Camden market, 2010

Covent Garden, 2010

"London is a large village on the Thames
where the principal industries carried on are
music halls and the confidence trick."

Dan Leno (1860–1904),
English music-hall comedian

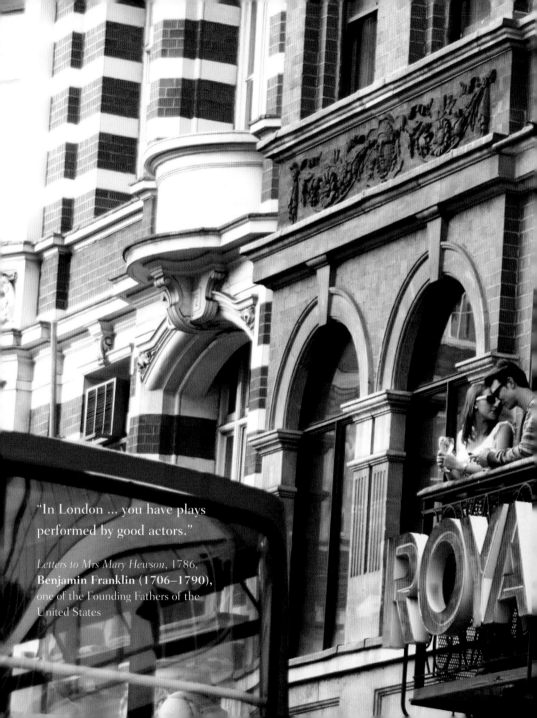

"In London ... you have plays performed by good actors."

Letters to Mrs Mary Hewson, 1786,
Benjamin Franklin (1706–1790),
one of the Founding Fathers of the
United States

Sloane Square, 2010

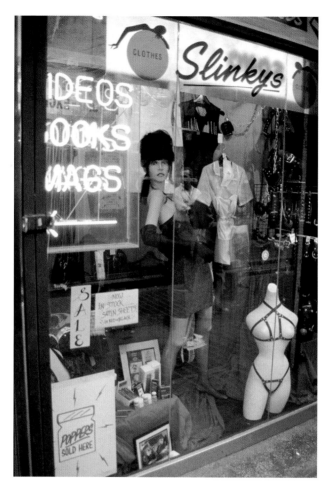

Soho, 1988

"If you get Sohoitis ... you will stay there always day and night and you will get no work done."

Memoirs of the Forties, 1965,
Julian MacLaren-Ross (1912–1964),
British writer

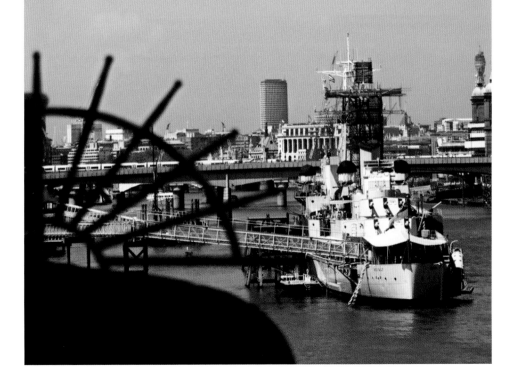

"The Tower Bridge ... or one of her
Majesty's battleships, and the Houses
of Parliament, all making good pictures
... but never attempt to Tattoo yourself,
as it is impossible."

How to Tattoo, 1896,
David W. Purdy,
British tattoo artist

Piccadilly, 2010

"During dinner at the Ritz
Father kept on having fits,
And, which made my sorrow greater,
I was left to tip the waiter."

Father, from *Rutchless Rhymes for Heartless Homes*, 1899
Harry Graham (1874–1936),
English poet and humorist

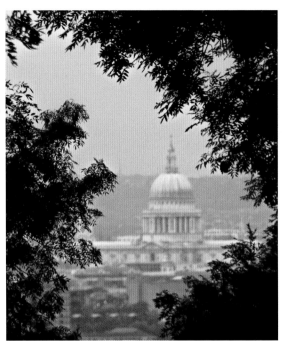

From Nunhead Cemetery, 2010

"That sense of vastness and illimitable proportions."

Autobiographical Sketches, 1853,
Thomas de Quincey (1785–1859),
English author and intellectual

From Greenwich Park Hill, 2010

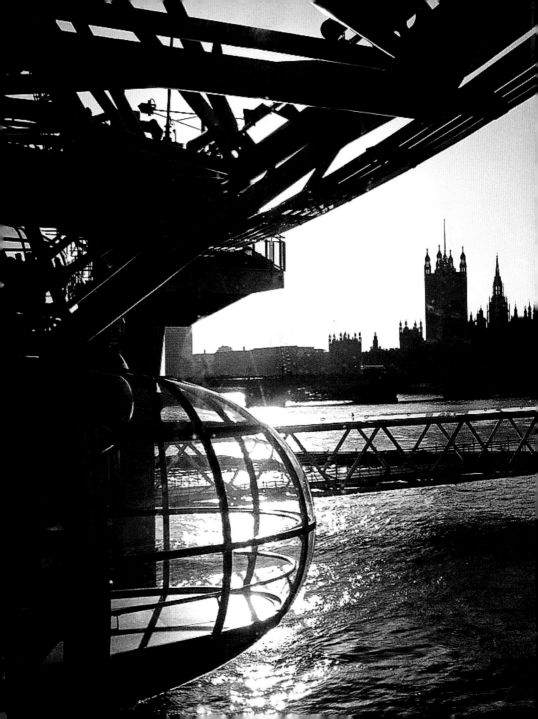

"I send, I send here my supremest kiss"
To thee, my silver-footed Thamasis."

His Tears to Thamasis,
Robert Herrick (1591–1674),
English poet

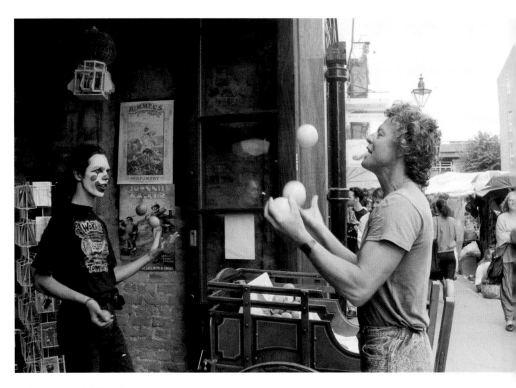

Portobello market, 1994

"Oh London is a dainty place,
A great and gallant city!"

London is a Fine City, street ballad, 1789

"I must have a London audience.
I could never preach, but to the educated."

Mansfield Park, 1814,
Jane Austen (1775–1817),
English novelist

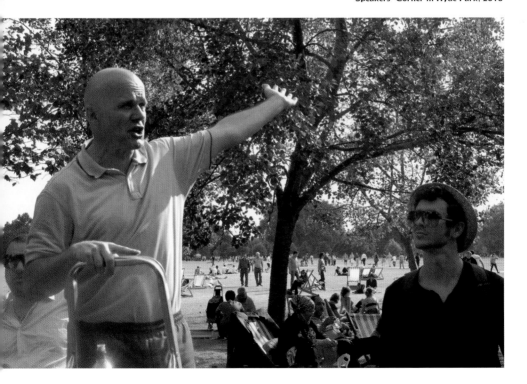

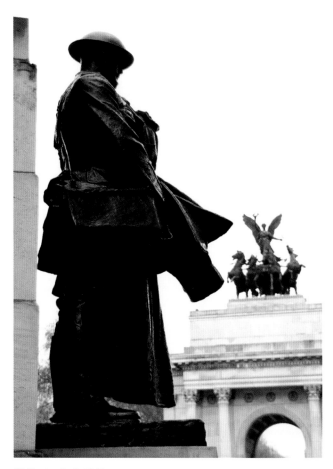

Wellington Arch, 2010

"This vast city, the mansion house of liberty."

Areopagitica, 1644,
John Milton (1608–1674),
English writer, poet and thinker

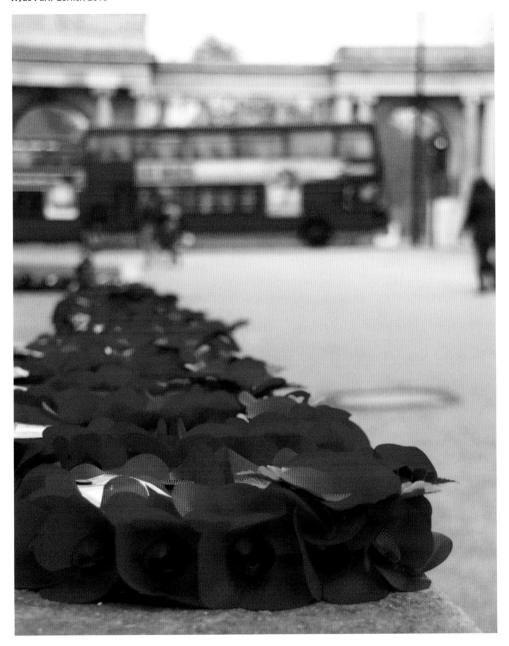

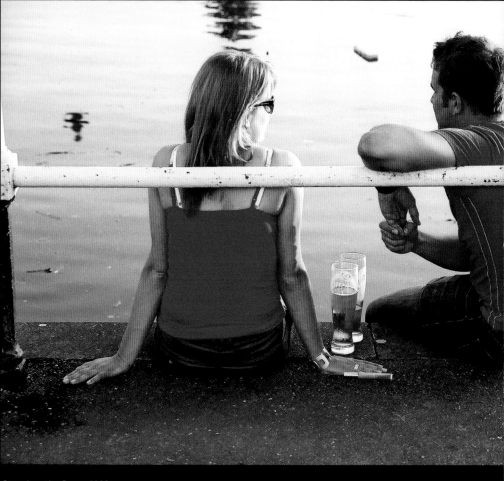

Strand-on-the-Green, 2009

"Would I were in an alehouse in London."

Boy, *Henry V,*
William Shakespeare (1564–1616),
English dramatist

Canary Wharf from Wapping. 2010

"Explore Wapping."

Samuel Johnson (1709–1784),
English writer and lexicographer

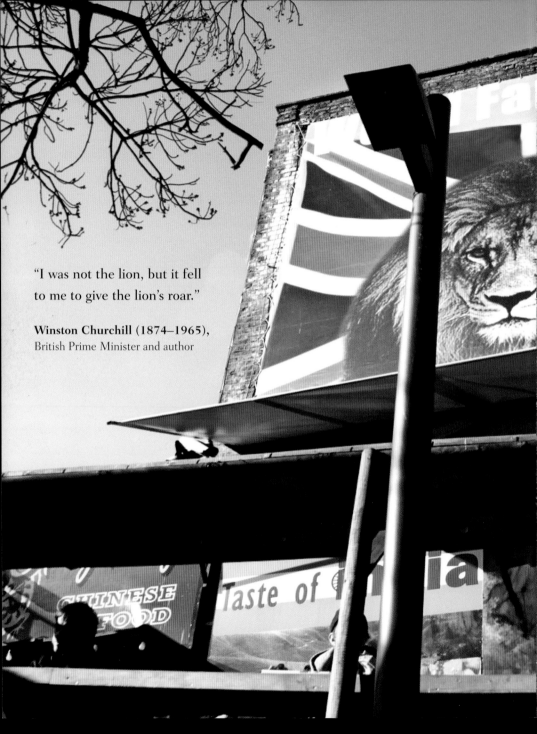

"I was not the lion, but it fell to me to give the lion's roar."

Winston Churchill (1874–1965),
British Prime Minister and author

Camden market, 2010

Victorian post box detail, Chelsea, 2010

"London doesn't love the latent or the lurking ...
It wants cash over the counter and letters ten feet high."

The Awkward Age, 1899,
Henry James (1843–1916),
American-born British writer

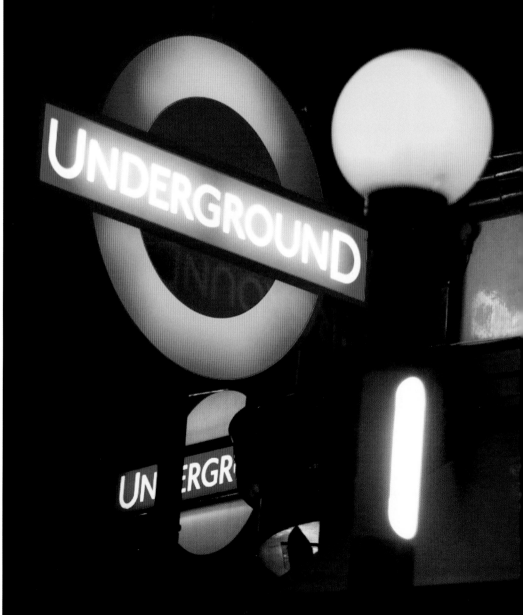
Covent Garden, 2009

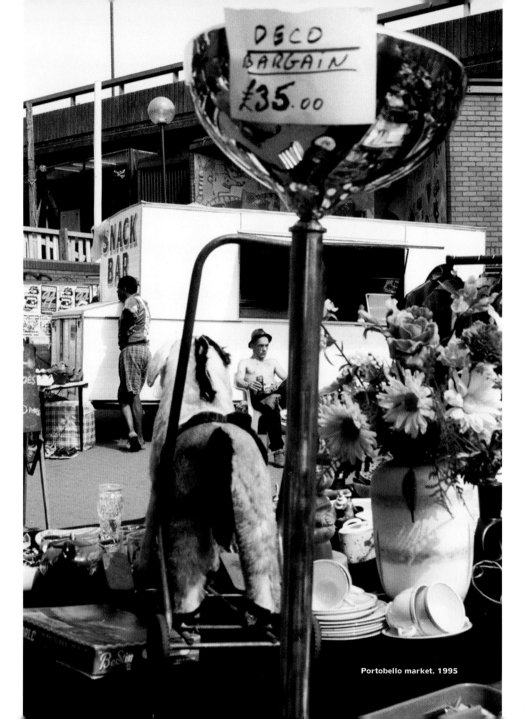

DECO
BARGAIN
£35.00

SNACK
BAR

Portobello market, 1995

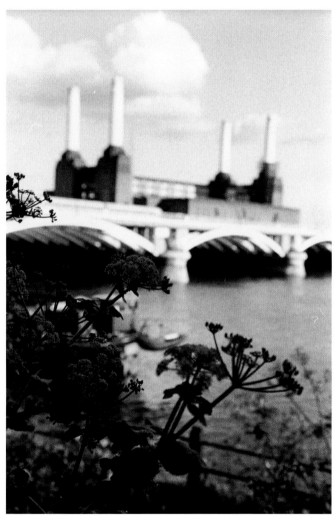

Battersea Power Station, 2006

"When it's three o'clock in New York,
it's still 1938 in London."

Bette Midler (1945–),
American singer, actress and comedian

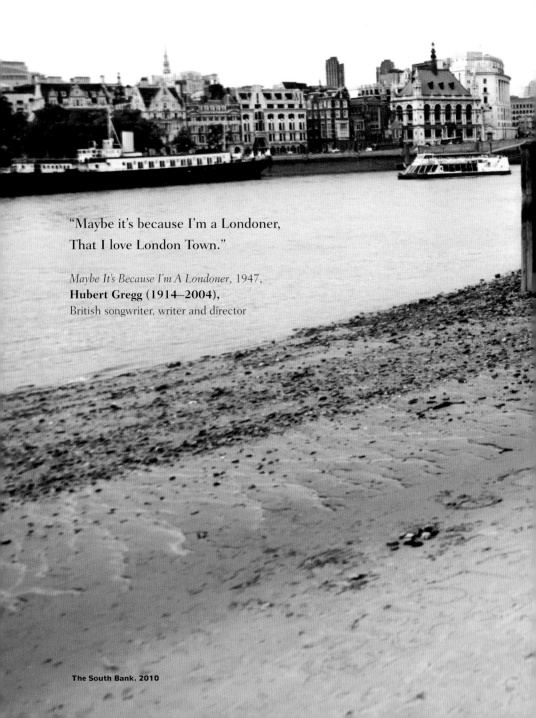

"Maybe it's because I'm a Londoner,
That I love London Town."

Maybe It's Because I'm A Londoner, 1947,
Hubert Gregg (1914–2004),
British songwriter, writer and director

The South Bank, 2010

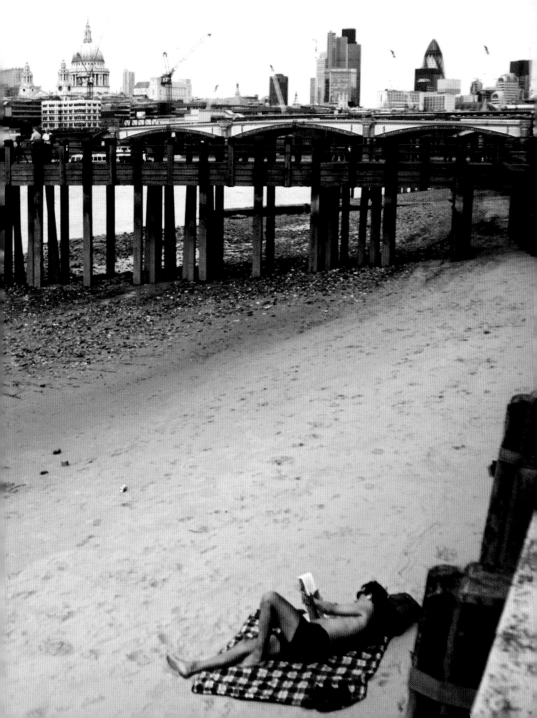

Acknowledgements

Every effort has been made to contact copyright holders of the brief quotations accompanying the photographs in *Love London*. The author and publisher offer sincere apologies for any inadvertent omissions, which will be gladly rectified in any further editions.

Grateful thanks to authors, publishers, estate holders and/or agents, for permissions to reprint quotations from the following authors.

W.H. Auden, *The Londoners*, 1938; by permission of the Estate of W.H. Auden, and The Wylie Agency, page 52.

John Berger, *The Guardian*, 1987; by kind permission of the author, page 8.

Malcolm Bradbury, *Eating People is Wrong*, 1959, Secker & Warburg; by kind permission of Macmillan and Curtis Brown, page 20.

Noël Coward, *Law and Order – Collected sketches and lyrics*, 1928; by kind permission of Alan Brodie Representation, on behalf of NC Aventales AG, successor in title to the Estate of Noël Coward, page 90.

James Dowsing, *Byways of Westminster*, 2001, Sunrise Press; by kind permission of the author, page 157.

Alan Gilbey, *Shoreditch*, 1998, commissioned by London Underground; by kind permission of the author, page 129.

Harry Graham, *Ruthless Rhymes for Heartless Homes* and *More Ruthless Rhymes*; by kind permission of Dover Publications Inc., page 172.

Hubert Gregg, *Maybe It's Because I'm A Londoner*, 1946; by kind permission of Mrs Carmel Gregg, page 190.

Geordie Greig, *The 1000, Evening Standard*, 2010; by kind permission of the author page 50.

Zaha Hadid; *ES Magazine*, 2009; by kind permission of the author, page 144.

Seymour Hicks; with kind permission of the actor's granddaughter, Lucia Stuart, page 26.

Ron Jolley, *Cockney Poem*, 2009, www.pearlysociety.co.uk; by kind permission of the author, page 72.

Julian MacLaren-Ross, *Memoirs of the Forties*, 1964; with kind permission of the The Estate of Julian MacLaren-Ross, page 170.

Louis MacNeice, *Autumn Journal, Part 4*, Faber & Faber; by kind permission of David Higham, page 134.

Spike Milligan, *Silly Verse for Kids*, 1959; by permission of Spike Milligan Productions, page 75.

Adrian Mitchell, *Celia, Celia*, from *Heart on the Left*, 1997, Bloodaxe Books; by permission of United Agents, page 127.

H.V. Morton, *In Search of England*, 1927, page 24; and *In Search of London*, 1951; pages 94 and 156; by kind permission of Methuen.

V.S. Naipul, *Heart of Darkness*, 1964; by permission of the author and The Wylie Agency, page 92.

Radio 4, *London: Another Country?*, July 2010, page 6.

George Bernard Shaw, *Pygmalion*, 1913; by kind permission of The Society of Authors as the Literary Representative of the Estate of George Bernard Shaw, pages 22 and 55.

Vincent Van Gogh, *letter 039*, to Theo Van Gogh, Paris, 1875; translation by kind permission of Van Gogh Museum Amsterdam (Vincent Van Gogh Foundation), page 36.

Virginia Woolf, *Diaries 1915–1941*, edited by Anne Olivier Bell, published by Hogarth Press; by kind permission of the Random House Group; page 76.

Virginia Woolf, *The London Scene*, 1934; by kind permission of The Society of Authors as the Literary Representative of the Estate of Virginia Woolf, page 105.

Benjamin Zephaniah; by kind permission of the author and United Agents, page 67.